Art Classics

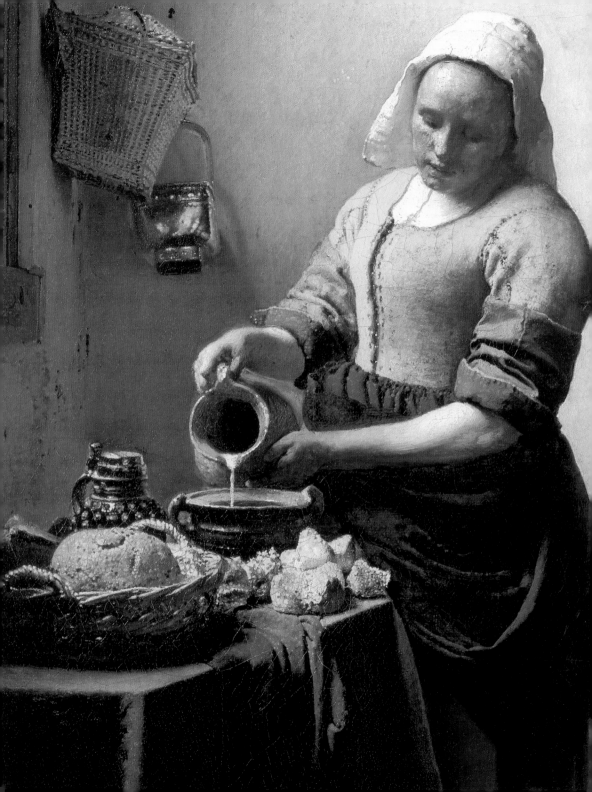

Art Classics

VERMEER

Preface by Giuseppe Ungaretti

Art Classics

VERMEER

First published in the United States
of America in 2005 by
Rizzoli International Publications, Inc.
300 Park Avenue South
New York, NY 10010
www.rizzoliusa.com

Originally published in Italian by
Rizzoli Libri Illustrati
© 2004 RCS Libri Spa, Milano
All rights reserved
www.rcslibri.it
First edition 2003
Rizzoli \ Skira – Corriere della Sera

2005 2006 2007 2008 2009 /
10 9 8 7 6 5 4 3 2 1

Printed in China

ISBN: 0-8478-2680-5

Library of Congress Control Number: 2004099913

Director of the series
Eileen Romano

Design
Marcello Francone

Editor (English edition)
Julie Di Filippo

Translation
Carol Lee Rathman
(Buysschaert&Malerba)

Editing and layout
Buysschaert&Malerba, Milan

Cover
Girl with a Pearl Earring
(detail), *c.* 1665
The Hague, Koninklijk
Kabinet van Schilderijen,
Mauritshuis

Frontispiece
The Milkmaid
c. 1659
Amsterdam, Rijksmuseum

The publication of works owned by
the Soprintendenze has been made
possible by the Ministry for Cultural
Goods and Activities.

© Foto Archivio Scala, Firenze,
2003

Contents

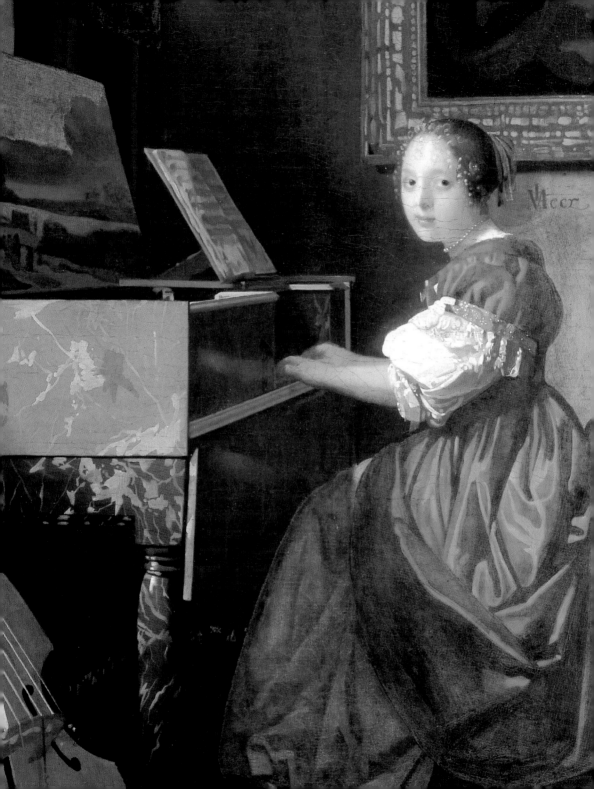

The Invention of Modern-Day Painting
Giuseppe Ungaretti

Vermeer's fate is one of the most extraordinary, not so much for his late arrival to fame as for the light of definitive glory cast on him by Marcel Proust's praise. It is known that the painter did not arouse a great deal of attention until 1866, when Théophile Thoré, better known by his pseudonym Willem Bürger, wrote his essay on him. It is extraordinary that even as a man Vermeer managed to avoid leaving any trace of himself to posterity except what came from simply leading his life as a good father and respectable citizen of Delft. The most striking thing that befell him was that he was chosen as headman by the associates of his guild. According to some, he was a Catholic at a time in Holland when it was not always easy for those who were to carry on in complete tranquility. However, neither his painting nor his biography reveals that religious problems caused him any trouble or even concern.

But Vermeer's painting is unusual for its own time and before, unusual in the Netherlands, and even elsewhere. By the painters who came before him or were his contemporaries in Europe, only one painting comes close. It is Piero della Francesca's *Madonna and Child* located in Urbino. I was surprised to realize this a few months ago, when I went back to visit the Galleria di Palazzo Ducale. Now reading up on it in the most recent books on Vermeer, I have discovered that Roberto Longhi, in his first essay dedicated to Piero, had already seen and pointed out this precursor, and there is no doubt that, as far as painting is concerned, no one has sharper eyes than he.

The construction of Piero's figures, in that painting as always else-

A Young Woman Seated at a Virginal (detail), *c.* 1675 London, National Gallery

where, is incredibly compact and solid, and for every one of them, in the concreteness of the physical volumes, what stands out is their majesty, which raises them above their human condition. To the right of the observer, in another room, there are two adjacent windows, illuminated together. Their light, reflected on the opposite wall, softly, looks in the reflection like a sliver of light with the same quality as shade, the quality of an incredible instability. Before the unstable verticality comes, the dark mantle on the Madonna's right-hand shoulder cuts it off and hides it. In that painting of Piero's, you can even glimpse at the far end of the opposite side of the main room, on the left-hand side, set apart above the head of one of the two angels on a shelf, a basket covered by a cloth. Above it, there must be a second shelf, almost invisible. Furthermore, the associations of the colors are obtained by using pale shades, as if the pure vigor of the expression could not be allowed, except on condition and by dint of having proven that it had that delicacy of touch that comes only from constant exercise of the sensibilities. What results is a closed setting, filled to the brim with silence. All elements which Vermeer was not to forget.

In Vermeer's paintings, the figures are not, nor do they attempt to be, majestic. They are people who, out of habit, do not break out of the limits set for middle-class life, and at the very most, could manage to select the limits sought by whomever is very simple in everything, even in feeling and imagining. This is not to detract from their profundity; indeed, it can give expression to the right profundity, the right degree of profundity, the degree that is a crucial aid in achieving a truth not beyond the reach of the human, a truth that, rather, is found in the very limits of the human, there, affirming the elusiveness of poetry, coaxing it out. It is one aspect that merits further study, the one from which Vermeer sees and attests, amidst the raging verism of other "lesser Dutch masters:" the rejection of their verism and every other form of verism, while remaining true to the truth.

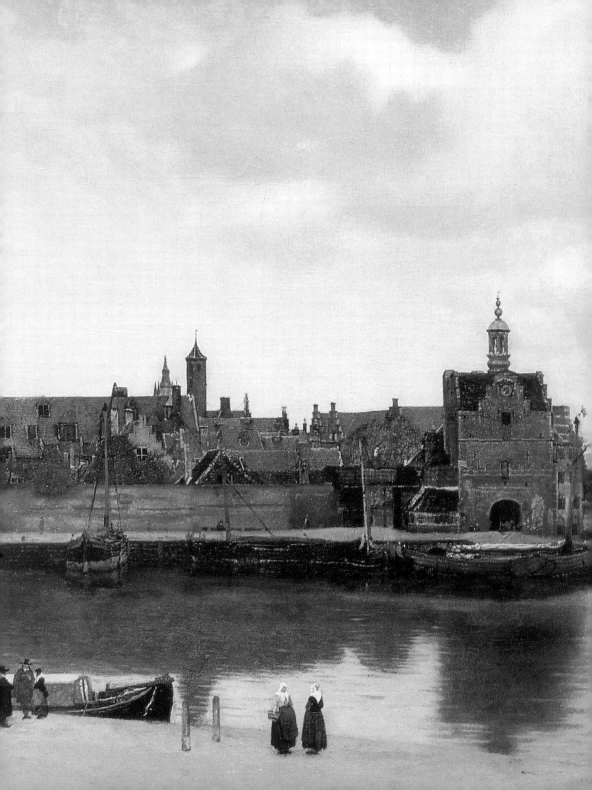

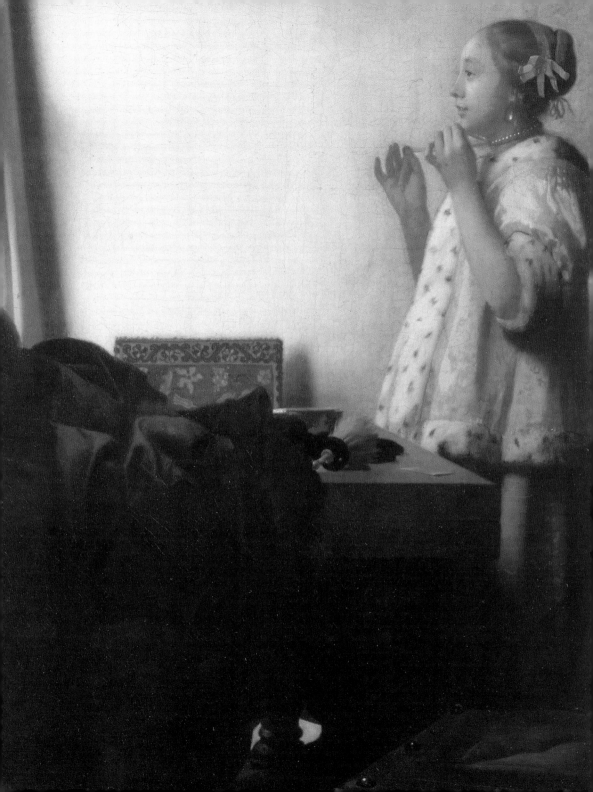

A thought has just occurred to me and I will write it down in the margin. At times, the faces of Vermeer's figures reveal strange or befuddled expressions, but this must have happened as a result of the havoc wrought by restorers without a care for defenseless layers of glaze. I can say this. Over the years, I have gone many times to Vermeer exhibitions and to the Dutch museums. At the recent exhibition in Paris, I was dismayed to see how many paintings had been mistreated, reduced to indistinctness where at one time the color, before they scraped it, was color, that triumph of color that Vermeer, in his entire oeuvre, never neglected or ceased to obtain.

From the very outset, Vermeer appeared as antagonist of the "lesser masters." Perhaps an unknowing antagonist. To put in plain sight to passersby, from the glass of the large window overlooking the street, shiny copper pots hung on the walls, Cordoba leather covers, chairs carefully carved of rare wood, furniture and every other kind of object, especially if exotic or precious, was and still is common in Holland, to show off one's own prosperity. The task of the "lesser master" was to paint, as if he were a passerby, that setting closed off only by the glass, and yet impenetrable, except by the eyes, to whomever was not of the same household or religious sect. The "lesser master" painted with a precision and a self-righteous torment with nothing in his head but making it look real, to do better than today's photography can do, but with the hope of not doing any more than what photography would have done later.

Even though Vermeer adopted the main purpose of the "lesser masters," which was to dedicate himself to interiors, to the so-called genre picture, he was still, in effect, seeking something else.

They call him the painter of light. They say he was looking for light.

Indeed, he was looking for light. You can see how it vibrates for him, from the windows, how it moves the shadow, the shadow of the light, the almost imperceptible shadow of the eyelashes as the beloved gaze drops slightly, a gaze that almost—in its lingering in the memory and longing—

11

imitates the mark of the shadow. But you have to be careful, talking about light. Perhaps, in seeking light, Vermeer found something else; perhaps the sublime wonder of his painting lies in this something else.

Many painters have tried to freeze light.

Caravaggio makes light smash reality to pieces, so he can then use those bits of light, with a crazy rage and joy of the senses, to erect an architecture of a different reality.

Rembrandt leads us to believe that he has obtained the privilege of having a philosopher's stone ready for his talent, to invoke a light of alchemy, captured when the sun strikes the glass and bricks of houses with an implausible weariness, yet is secretly exceedingly brutal. Then the lead melts, the gold explodes and devours like leprosy.

Poussin and Corot perpetuated—in different ways, but both of them astonished and rapt—the exact rendering in paintings of the Alban woods populous with fauns and nymphs, covered by a sky of pure blue, that sifts and scatters, below, its light, a light right for a paradise not yet lost.

Cézanne considered light in a dramatic way. He attempted to uphold, in spite of the light and still respectful of it, the volume of objects, the volumetric developments that a painter's intellect and imagination can coax from the objects.

Seurat constructs the ponderous volume of a figure purely by decomposing the light that envelops the figure in tiny points of color complementary to the eye's iris.

Actually, with the exception of Seurat, all the painters we have mentioned found something else, no longer the light, even if the light had been an indispensable aid in finding something else.

We could go on, listing throughout the centuries the painters who made use of the resources offered them by light. After all, without light, there would be no objects, it being impossible to identify them and name them before the human eye.

A Young Woman Standing at a Virginal (detail), *c.* 1672 London, National Gallery

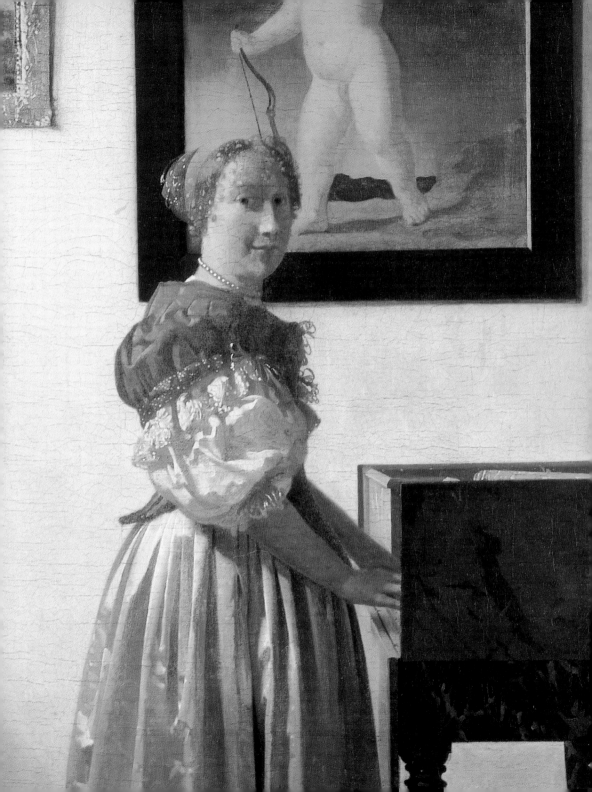

More than light, Vermeer found something else: he found color, real color, real in its absoluteness of color. If, in Vermeer's paintings, light counts, it is because light, too, has a color: the color of light. Vermeer sees that color as a color in itself, like light, and he sees, isolates, too (if it is seen), its shadow, an indissoluble condition of the light. Not even volumes count for him, steeped in light, macerated in light, pitched forward, with big, pregnant bellies, with such modesty, such anxiety, such sweet apprehension that he portrayed. The color counts. Are they ghosts, the people portrayed, the wife, the daughter, the painter himself? Those familiar people depicted, those household objects suggested? Maybe. The truth lies in the right degree, though it manages to evade it and become metaphysical, turning into an idea, an immutable form, becoming in the end, if not pure color, a better, wise, measured distribution of pure colors, interpenetrating one another, isolating themselves from one another.

Once, thinking about the relationship between art and life, Jan van Eyck came to mind. I realize that we are talking about a painter who worked about two centuries before Vermeer, and that he was a Flemish painter. The centuries matter up to a certain point for what I am about to say. Flanders is certainly different from Holland, but the Dutch and the Flemish are cousins at least. There you are, in the Bruges museum with the *Madonna of Canon van der Paele*. There are five figures in the painting and four of them—a bishop, a soldier, the Madonna and child—remain intentionally imaginary.

When, for example, Piero della Francesca thinks of a saint, he never forgets that, in order to justify him in terms of human feelings, he will have to find, through his painting, a relationship between the idea of holiness and a real, flesh and blood person.

In the case of the canon, van Eyck is instead concerned with nothing but the contrast between reality and imagination; but he does not arrive at any contrast: the two parts of the painting are in all respects

irreconcilable, as there is absolute incompatibility and not even the smallest scrap of drama. It is a typical example of incommunicability. He has not the slightest idea of how to moderate his imagination, and attains results of consummate refinement, but there no longer seems to be any relationship with the human being. And if he overwhelms the viewer through his genius and mystical transport, he still fails to reach him on a human level and convince him. As for reality, it is as if such an absurd waste of imagination that he devotes to the first four figures, as I was saying a minute ago, was not there, before the canon's eyes, telling him that it was a senseless illusion to believe in it.

The figure of the canon, the donor, the fifth person is instead so foreign to the painting that he seems to have been inescapably expelled. Not at all pious, his kneeling aside, almost at the level of the floor where he is situated, he is mighty, compact, overbearing, stentorian in the midst of the comings and goings of the visitors: in fact, his call to halt manages to paralyze us. Let us overlook the spectacles, the breviary, and all the heaps of details that are not an integral part of the figure, and observe the face, which is painted, unlike the others, with an agonizing, analytic care: each wrinkle is inflicted on it with a ruthless confidence, as the furrow of the plough is to an unwilling soil. The painter then lingers, as if he could not pull himself away from them, over the map of veins on his forehead. (Did the canon suffer arteriosclerosis?) By now, the painter has reached the eyes and agonizes over (clearly, for him it is a treat) crows' feet and bags.

So, agonizing, examining, torturing that poor flesh until, having wanted to put in so much life, there is nothing left for van Eyck, if not a muddled web of signs that the man is caught in, like a fly.

Was this reality, this "life" of van Eyck's, the point of departure for the "lesser masters?" Life and reality are two different words for saying the same thing. In any case, these painters do not even look for, or know about

following pages
Diana and Her Companions (detail), *c.* 1655 The Hague, Koninklijk Kabinet van Schilderijen, Mauritshuis

15

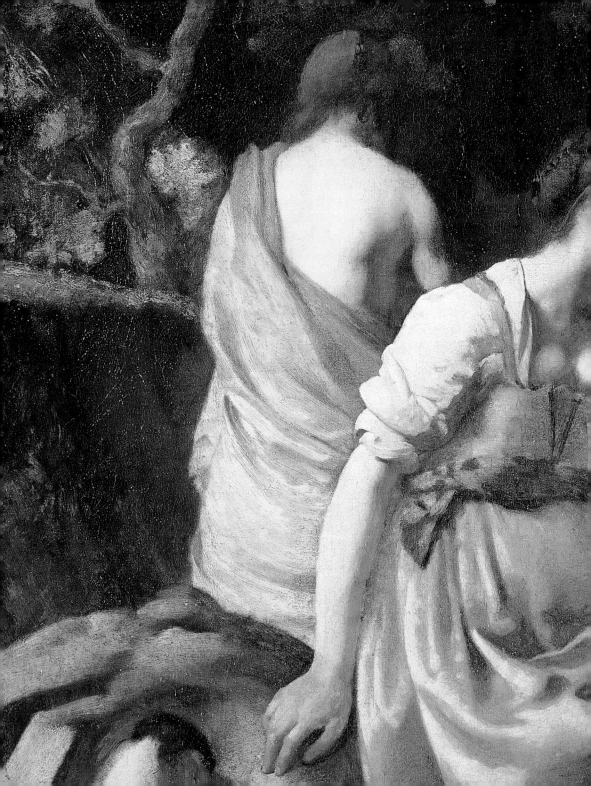

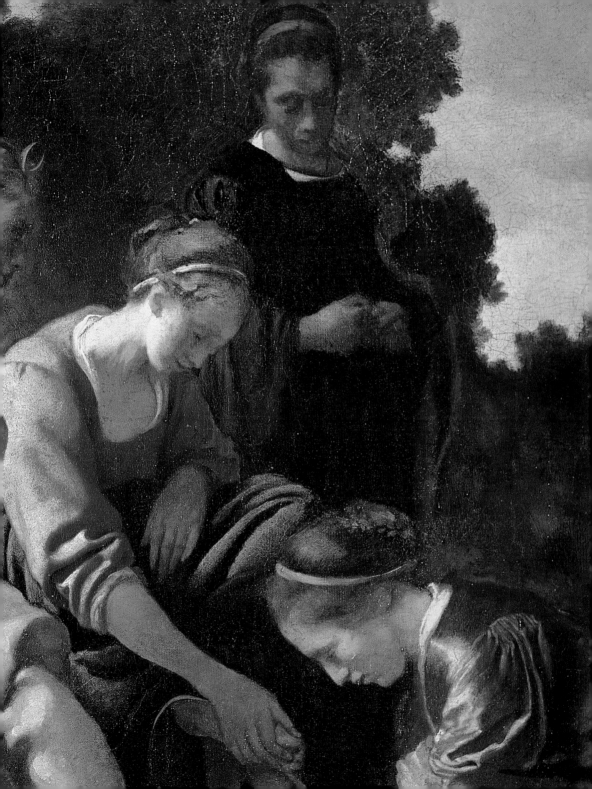

the contrast between reality and idea; they only paint reality, and they are right. Reality is inseparable from the idea, and if the idea is lacking, it is better not to make, as van Eyck did that time, monstrous combinations.

To make myself more understandable, I can say that in Rembrandt's *Anatomy Lesson*, the idea (death) and life (the corpse ransacked by the doctors) are inseperably, indissolubly joined in the same person, and also, to death is joined the idea of man's (vain) struggle (knowledge in continual progress) against death. Elsewhere, in the *Jewish Bride*, there will be life, in that prosperous, fascinating girl, and the idea of the ephemeral, made so poignant in the caducity of that fine figure in its glittering wrap, triumphant yet lasting no more than an instant.

Vermeer's equilibrium is constant; he achieves it without effort, without the least fatigue, right away, spontaneously, by the simple, immediate joining of inspiration to the form, of a spark identified in the form.

The Lacemaker is curved over her work. Her gaze is concentrated; she is absent from anything around her that is not her work, that movement of fingers knotting the threads in enchanting weaves. Fingers and gaze move ceaselessly, frozen forever in movement. The idea of infinity, of familiarity with silence, solid, indissoluble, and unbreakable silence; the idea of an immutably, happily ordinary, simple existence; the idea of an utterly solitary solitude, with all the rest mute; this is the idea. Perhaps it does not have the same proportion, is not equal, or have the same depth; perhaps it is not at the same level, or does not share the same secret of the painting that shows it. No, no one could say this, no one. Some examples? *A Lady Writing a Letter*. Whatever does she have to say? Her broad forehead is turned slightly to the side, sloping toward thoughtful eyes. She is trying to connect. Too many thoughts jostle in her mind. Her fingers taper, showing the grace of caressing hands, a little plump, resting on the sheet, one abandoned, the other gripping the pen, anxious to return to crafting her loving sentences.

View of Delft (detail), c. 1660 The Hague, Koninklijk Kabinet van Schilderijen, Mauritshuis

18

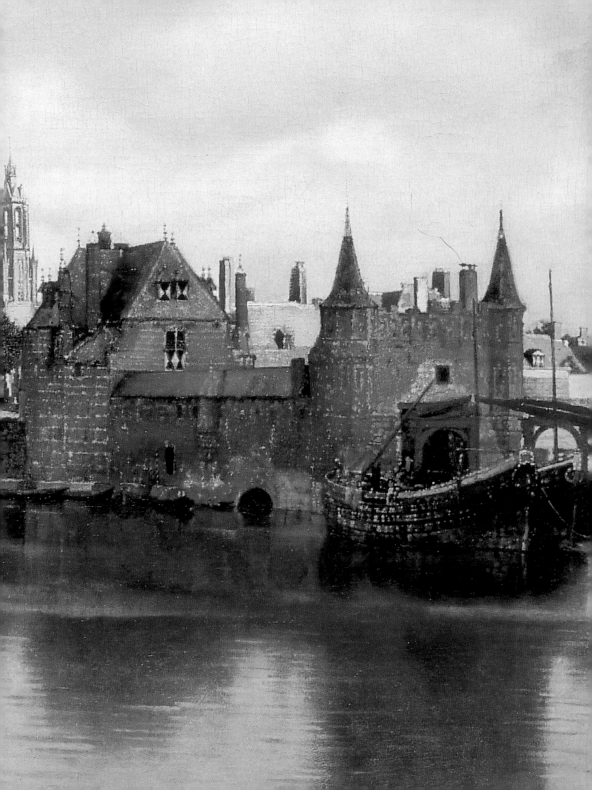

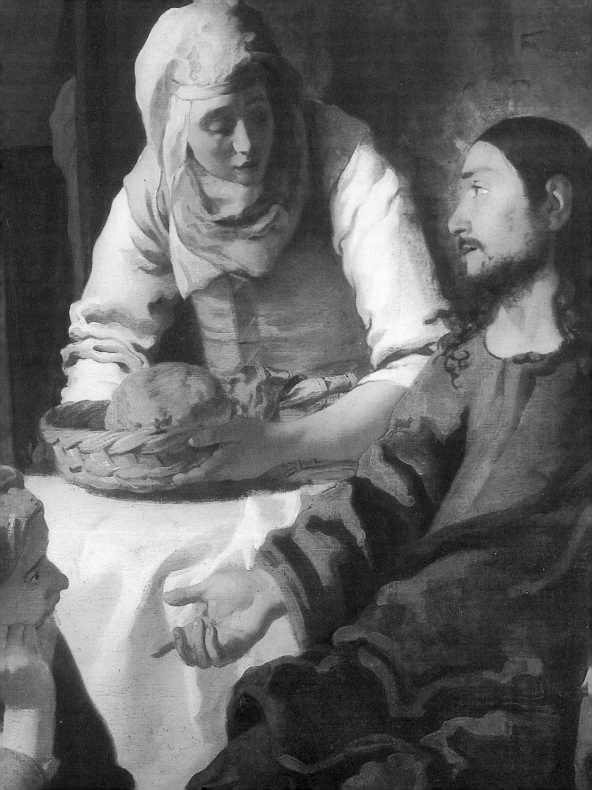

How could there possibly be a better way to freeze forever the idea of absence? Not a distressing idea: an idea of infinite tenderness, with just a whisper of melancholy. It is the richness of a young female's, a human being's, solitude, of a young woman who gazes without fixity or fixation, but with a sweet ardor that rises from the soul, invoking the missing one, without disturbing the silence, infinitely heightening it.

Have form and content ever achieved, merging together, greater precision in describing the human condition?

If I had to sum up what I have said about Vermeer so far, in so many words, I would say that we must already have some notion about what distinguishes him from his contemporaries, the "lesser masters;" about the importance that light holds for him, considering and deeming it the soul of every color; about equilibrium and the connection between art, idea, and life that he achieves in his paintings, as he sees, feels and imagines it, respecting the figures and the objects according to the natural appearance of their reality.

I will have to return to talking about color. Proust may not have been a man of impeccable taste. He lived close to Montesquiou, was crazy about Gallé glass, was a devotee of art nouveau style ad nauseam, to the point of obsession, and if we heard him talking about music today, we would stone him. But in his days, the horrible belle epoque, he doubtlessly had more taste than everybody else. I quote some passages from Proust: "You must have seen some of Vermeer's pictures, you realize that they are the fragments of the same world, that, whatever genius recreated them, it is always the same table, the same carpet, the same woman, the same fresh and unique beauty, enigma, in that time when there was nothing like it and nothing to explain it, if you don't try to relate it to subjects, but instead isolate the particular effect of the color.

"A critic, having written that in the *View of Delft*, a painting that

Bergotte adored and thought he knew very well, a patch of yellow wall (he did not remember it) was painted very well, that it was, if you looked at it alone, of a beauty that was enough in itself [...].

"He repeated [the anguished Bergotte]: a patch of yellow wall with a sloping roof beneath it, a patch of yellow wall."

The great painter Vermeer was discovered, the predecessor, the one abstract painting had awaited, the one who had to keep his patience until the second half of the twentieth century to be understood and to have a following among painters.

How did Proust have, in this case, the insight and finer taste than, I say, not only his contemporaries, but also all of us living nearly a half-century after his death?

Look at *The Way*, or *The Little Street*, as some prefer to call it. Its flat, construction, with slabs of garnet and gray, where only the difference of shade indicates their time, their state, the appearance made immutable by the hand of art, in that ephemeral moment of that day. The new and terrible beauty of a house.

In *The Concert* it is the advent of the color yellow. The girl is at the virginal. The folds of the dress modulate the yellow. There is the leather back of a chair, that reddish leather, it is an isolated absoluteness of color as in the famous yellow of the patch of wall. For the absoluteness of color, observe as well the bustle of people, the clouding over, the darkening of the black and white tiles of the floor in the same painting. I would say they were marble tiles; but perhaps this time, and who knows how many other times it has happened and will happen, my memory was not reliable. I will have to mention the yellow, the sulphurous yellow of the jacket of the *Lady Writing*, a painting I have already discussed here, and it is an invasive yellow, a high-handed yellow. The same yellow is repeated in *Mistress and Maid* with the same jacket, and again the same jacket appears in *Woman with a Pearl Necklace*.

There is also the blue to discuss, of varying intensities, a color no less important than yellow in Vermeer's palette.

And what can we say about the red? For example, that red in *Girl with the Red Hat*? It is a scarlet red, a blood red, a fire red. It is the feathers, light, raging feathers that seem to become annoyed and fussy over the slightest breeze, and, thanks to them, what magnificence invades the painting.

An array of bright reds, blues, yellows and, in the brightness, when necessary, a hint of gray or brown. Here is Vermeer. The inventor of the finest painting of today. But this "here" seems to me to be an immensity.

His Life and Art

The Dutch painter Johannes Vermeer (1632–1675) is considered the greatest exponent of a particular kind of genre painting depicting scenes from everyday life in elegant bourgeois settings. Experts estimate that about thirty-six of his paintings have come down to us, although some scholars have cut that number, rejecting some of the attributions. Most of these works show domestic interiors with figures intent on simple activities; there are also two paintings with religious subjects, one mythological scene, two city views, two allegories and four studies of heads.

Vermeer shared his favorite themes with other leading artists of his time, such as Frans van Mieris, Gerard ter Borch, Gabriel Metsu and Pieter de Hooch. They, too, depicted ladies intent on reading or writing letters, girls at the mirror, small and elegant musical concerts and conversations; paintings dedicated to such domestic activities as embroidering and kitchen chores were also common in Dutch painting. Vermeer's paintings, however, differ from those of other artists depicting the same subjects for their rigorous rejection of anecdote. The selection of the figures and the objects represented makes his compositions essential, replacing narrative with descriptions of space, light and color.

Vermeer did not have a biographer, so that, despite the systematic study of archival documents by scholars, we still know very little about his life. The research, however, has yielded an intriguing picture of his family's affairs over three generations. In this context, recounted by notarial deeds and other sources of a legal sort, Vermeer cuts a minor figure. One plausible explanation for this might be that he dedicated himself almost exclusively to painting, managing in some way to isolate himself from the intricate dealings of his closest relations. The impossibility of fully reconstructing his historical figure has contributed to wrapping Vermeer in a veil of mystery, earning him the title "the sphinx of Delft."

The artist's father, Reynier Janszoon, came from a modest family of Delft craftsmen. In 1611, Reynier was sent to Amsterdam as apprentice weaver of *caffa* fabric, a rich cloth of silk blended with wool or cotton with damasked designs. Once there, he married a woman of Flemish origin, Digna Baltens. The couple soon moved back to Delft to join Reynier's family. In 1619, the family was involved in a grave legal matter: Digna's father and brother were caught in flagrante delicto working in the laboratory of a counterfeiter, and while the former managed to escape, the latter was arrested. Reynier and his mother, Neeltge, went into debt to free him. The woman, who had recently lost her second husband, traded in bed linens and second-hand articles. In 1620, perhaps to meet growing financial difficulties caused by the affairs of her in-laws, Neeltge took part in a fraud, with as its victim a wealthy merchant: the latter had entrusted her with obtaining authorization to organize a lottery of luxury goods, and she defrauded him by falsifying the public deeds. When she died in 1627, her home and her belongings were sold to settle the debts that she had not been able to pay.

In 1620, meanwhile, the first child was born to Digna and Reynier, a girl named Gertruy. These were years of hardship for them, too. For reasons unknown to us, they were in debt with Digna's father and were forced to hand over to him ownership of all their assets. Then, in 1625, Reynier took part in a brawl in which a soldier was mortally wounded. For some years, we have no news of him until 1629, when he is mentioned in a document as a tavern keeper. We can imagine that at that date he was already managing the tavern mentioned in later years, situated on the Voldesgracht canal, near the market square and called the Flying Fox. The name was a simple play on words using *Vos* (fox), the nickname. Reynier was known by at the time before taking on Vermeer as his surname. Two years later, he

registered with the guild as an art merchant: this business was conducted in parallel with that of innkeeper, as it was common in the Netherlands for taverns to host painting sales and auctions. We have little information as to the exact nature and volume of this trade. It is hard to believe that Reynier dealt in valuable works, but the documents do suggest that he was in touch with artists and connoisseurs and that the family milieu was crucial in deciding the choice of profession of Reynier's second-born, the future painter Johannes Vermeer.

Johannes was born in 1632 and baptized on October 31 at the Reformed Church in Delft, a fact that provides evidence of a Calvinist upbringing. The name given him was a Latinized version (and therefore considered cultured and elegant) of the more traditional Jan, which is often incorrectly used in studies regarding him. In 1632 Johannes's parents, who were then forty-seven and forty-three years old, declared in their will that the two children were to be provided with schooling sufficient to learn a "suitable trade." We do not know what the outcome of this plan was, as there are no documents to inform us, even indirectly, of Vermeer's training. After the date of baptism, we have to wait twenty-one years, until 1653, for further news about his life.

Meanwhile, in 1641, his family left the Flying Fox to found a new inn called the Mechelen, which overlooked the marketplace where the town hall and the Reformed Church also stood. The funds for buying the building, which the artist inherited in 1670 upon his mother's death, were raised by putting two mortgages on the property: these debts, too, were passed on to Vermeer, as his parents were not able to redeem them in the course of their lifetimes. Reynier died in 1652, and we can infer that at the time, the family had limited resources, since nobody made the offering that was usually paid in the name of the deceased to the Camera van Charitate, a city charity.

On April 4, 1653, Johannes Vermeer,

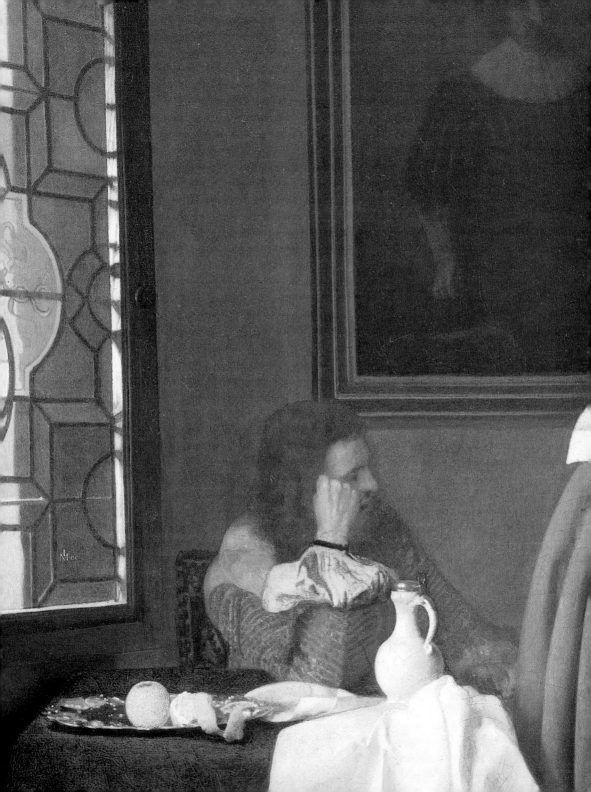

who by then must have finished his apprenticeship as painter, went to the home of Maria Thins to ask her consent to his marriage with her daughter Catharina Bolnes. The artist's future wife, who was one year older than he, was a member of a wealthy Catholic family from Gouda: she had moved to Delft in 1641 and lived with her mother and sister. Maria, in fact, had left her husband after years of abuse and violent quarrels starting when Catharina was only about four. Maria was subsequently granted a legal separation and a weekly payment while awaiting the division of property and the custody of the two daughters, but not that of the son Willem, who stayed with his father. The man, who in 1649 had to return to Maria half of the assets they had held in common, gradually let himself go to ruin, until in 1653, he declared bankruptcy. In the dispute between the two, Willem took his father's side, to the extent that once when he met up with his mother on a Delft street, he obscenely mocked her.

From a notarial deed it appears that Maria Thins refused to sign the document of assent to her daughter's marriage, even though she declared that she would not have opposed the publishing of the banns. We do not know the reasons for this strange stance; it could have to do with the fact that Vermeer belonged to a family of the Protestant faith, while the Thins family followed a strongly Catholic tradition. The woman may have, moreover, harbored reserves over the social status of her daughter's future husband, who descended from lowly innkeepers.

Vermeer and Catharina married on April 20, 1653 at Schipluy, a town near Delft where a Jesuit mission kept up a lively presence. Presumably, after the engagement, the painter converted to Catholicism. This decision, in fact, placed him on the fringes of the social order of the town, where the followers of the church of Rome were excluded from public office and heavily discriminated against by the Calvinists.

The couple's first daughter, Maria, must have been born about 1654. The family soon found itself in financial difficulty, and the two fell into debt. From the documents, we can deduce that the couple had opted for a separation of estates, perhaps to protect the sizeable estate that Catharina was to inherit against any bankruptcy on the part of the painter. In 1653, when he registered with St. Luke's guild, Vermeer paid a very low sum, and did not finish paying off the sum needed for admission until five years later. We do not know where the family lived in these first years: perhaps in the Mechelen inn, or perhaps with Maria Thins in the Catholics' district known as Papists' Corner. The presence of the artist and his wife in the mother-in-law's house is, in fact, documented from 1660 on. At that time, they already had three or four children, and another, a newborn infant, died that same year.

In around 1660, Catharina's brother, Willem, also arrived in town. The youth led a dissolute life, the economic burden of which seems to have fallen on the shoulders of his mother since his father was no longer able to provide for his needs. In 1663, the delicate situation deteriorated: on various occasions mother and son quarreled, and Willem hurled heavy insults against Maria, making threats. He turned his violence against his sister Catharina, as well, even though she was with child, soon to give birth. From a notary's record of the vivid testimony left by the neighbors who interceded in defense of the women, it appears that the painter was completely unconnected with all this: there is no mention of him at all. Maria finally managed to get the authorities to commit Willem to a private reformatory. In 1666, when he broke out of his prison to marry one of the institution's servants, Vermeer's mother-in-law contested the marriage, collecting testimony sufficient to discredit the aspiring wife, accused of being a thief and a liar. In the years that followed, Maria's main concern seems to

have been that of guaranteeing a prosperous future to the many children of Catharina, to whom she allocated most of her family assets. Her rapport with the painter, which initially had been somewhat cool, improved over time: in 1667, she even appointed him the administrator of her estate.

We must assume that in the meantime, Vermeer kept busy primarily with his art. Of this activity, however, we know little in concrete terms. There is no direct documentation, for example, of his relationship with patrons or clients. The only sure piece of information is that he was nominated head of the painters' guild in 1662 and again in 1670. This is undoubtedly an indicator of the respect he had acquired in Delft's small artistic community; in passing, this is also the only detail we have about his involvement in town life, apart from an enrollment in the registers of the civic guard in 1674. In any case, that Vermeer was a renowned painter is confirmed by the fact that two gentlemen of the time recorded in

their diaries that they visited his atelier. The first was the Frenchman Balthasar de Monconys, who in 1663 was in Delft for one day in the company of a Carmelite priest and another Catholic (who some have suggested was the painter Louis Cousin). On that occasion, the artist did not have with him any of his works; the threesome, however, could see one of his paintings at a baker's. The painting had cost a sum that the Frenchman considered excessive, especially since the composition included just one figure. Later, in 1669, Pieter Teding van Berckhout reported having been to see Vermeer twice, and expressed particular appreciation for his skill at rendering perspective. That same year, the young art lover, who was a member of the Protestant high society, had visited the studios of Cornelis Bischop, Caspar Netscher, and Rembrandt's celebrated pupil, Gerrit Dou.

In 1672, Vermeer was called to The Hague together with a colleague to evaluate paintings, mostly by Italian artists, that the prominent merchant of Amsterdam, Gerrit Uylenburgh, had proposed to the Great Elector of Brandenburg, Frederick William. According to the painter Hendrick Fromantiou, who acted as agent and advisor to the prince, the paintings were fakes, and therefore had to be rejected. A long dispute followed, and the two rival parties called upon famous artists to judge the paintings. On the day in which Vermeer was asked to express his opinion about the matter, the famous statesman and intellectual Costantijn Huygens wrote in a letter that the controversy was born of Fromantiou's dislike of Uylenburgh, and that the paintings were doubtlessly authentic. Vermeer and his colleague Johannes Joardaens, who had spent a great deal of time in Italy, instead declared that the paintings were not, as the dealer claimed, precious originals by such masters as Michelangelo, Titian, and Tintoretto, but rather, "daubs and bad paintings" that were not at all worth the prices asked. From what we have been able to

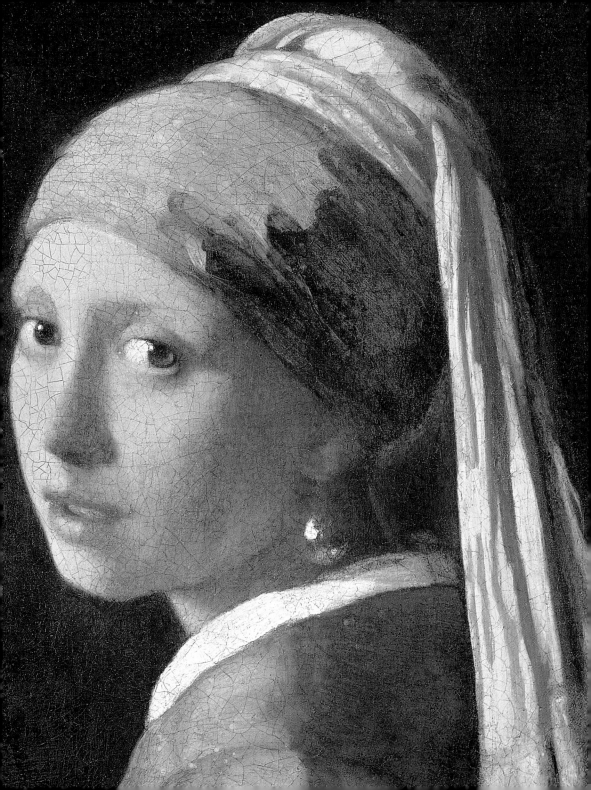

reconstruct, it appears that the paintings, in effect, were not authentic, but works from the school or shop of the artists; Frederick William, in any case, managed to return them to Uylenburgh, who put them up for auction the following year at Amsterdam. Critics have often interpreted the call for Vermeer's opinion as proof of his knowledge of Italian art; more likely, it can be seen as proof of the fact that at the time, the painter was known and esteemed even outside Delft.

An evaluation of Vermeer's volume of affairs has been attempted on the basis of the scant documentation available. It seems safe to say that it was not sufficient to maintain his family, which relied primarily upon Maria's and Catharina's incomes; after all, allowance must be made for the fact that the two women were accustomed to a rather luxurious and costly lifestyle. It appears that the painter, like his father, dealt in other artists' paintings: the information available to us (an inventory with estimates drawn up upon the artist's death) suggests that this income was not significant either. In 1670, following the deaths of his mother and sister, the artist inherited a small sum, the right to collect debts, and ownership of the Mechelen, which at the time was still mortgaged and yielded only a modest rental income.

Vermeer's economic situation worsened with the dramatic events that took place in Holland in 1672–1673; the French army under Louis XIV invaded the Netherlands, sacking and devastating the land. To impede the occupying forces, the Dutch flooded the territories, opening the dykes that usually protected them from the sea: by the end, the Dutch War left poverty and destruction. Catharina Bolnes declared that the tragic conflict with France caused the painter serious hardships: he was unable to sell either his own art or that of the other painters he was dealing in. In the following years, perhaps to cope with the growing difficulties, Vermeer dedicated himself

actively to the administration of his wife's
and mother-in-law's estates, squeezing some
revenue from them, and looking after the
estate of Maria's husband, who died in 1674.
In July of that same year, the artist traveled
to Amsterdam to ask for a rather sizeable
loan: it appears that in this case, he had
acted against the wishes of his mother-in-
law, and even against the law, though the
details of the affair are not completely clear.

In December 1675, at the age of forty-
three, Johannes Vermeer unexpectedly died;
he was buried on the fifteenth in his family's
tomb. His wife Catharina said that the
economic consequences of the war had been
disastrous, and that the painter, "also
because of the great burden of raising his
children, and having no means of his own,
had fallen into such a ruinous state and deca-
dence, which he had so taken to heart that
he lapsed into a sort of delirium, so that in a
day or a day and a half, he went from being
healthy to being dead." From this tragic, but
also somewhat ingenuous account, we can

deduce that the artist was the victim of a stroke, the consequence of the all-consuming economic worries connected with the maintenance of his large family. According to the widow's later statements, Vermeer died leaving ten children still minors, the youngest of whom was perhaps net yet even two.

The family's situation was as bad as it was partly because many of Maria's and her daughter's assets were tied up. In 1676, Catharina appealed to the High Court to declare bankruptcy and request a moratorium in the payment of the debts left by her husband upon his death. The municipal authorities then appointed as trustee of the estate the scientist Antony van Leeuwenhoek, born in Delft the same year as Vermeer and famous for his microscope research. Biographers have assumed that the scientist and artist shared a bond of friendship, and this was the reason why he was chosen to be trustee. The hypothesis, though particularly interesting as far as a reconstruction of the intellectual figure of

Vermeer, is not confirmed by van Leeuwenhoek's behavior in the circumstances. It appears that he was rather severe with the artist's widow, going so far as to accuse her and her mother of maneuvering to remove assets and money from the liquidation of debts. In effect, after Vermeer's death, Maria redrafted her will several times, reducing to a minimum the estate left to her daughter, declaring that the amounts she loaned for the upkeep of the family were to be detracted from the total bequest. In this way, at her death, nearly all her assets passed directly to her grandchildren. From the documents available, it seems safe to assume that Catharina entrusted to her mother luxury objects that she presumably owned before her husband's death so that they would not be sold to pay off creditors. The intrigue is apparent in a case that takes on particular resonance in this respect: with a special deed, in fact, Vermeer's widow ceded to her mother the painting known as *The Art of Painting*, alleging that it was security

for a loan. It appears that van Leeuwenhoek later included the painting in an auction list, drawing the protests of Maria, who claimed legitimate ownership of it. How the matter ended is not known, but one gets the impression, in any case, that the artist's wife was trying to conserve a work that Vermeer kept for himself for many years after painting it.

Before van Leeuwenhoek's involvement in the management of the estate, Catharina had already paid back the baker Hendrick van Buyten, who claimed a considerable credit: it has been estimated that the figure owed corresponded to the amount of bread needed to supply Vermeer's populous household for two or three years. Not having the cash available to pay the baker, the widow gave him two paintings that had been left in her husband's studio: one showed a woman playing a guitar, and the other, two figures, one seated and writing a letter. The paintings can prob-ably be identified as *Guitar Player* (London, Kenwood, Iveagh bequest) and *Lady Writing a Letter with Her Maid* (Dublin, National Gallery of Ireland). The information is all the more interesting when seen in light of the travel diary of the Frenchman Monconys, who mentions having gone to a baker's in 1663 to view an unspecified painting of Vermeer's, for which, in the visitor's opinion, the baker had paid too dear a price. Van Buyten was one of the richest men in Delft, and he owned an outstanding collection of paintings, including, at the time of his death, three Vermeers, all purchased prior to 1683. We do not know what their subjects were, but we can obviously assume that two were the paintings obtained as loan security from Catharina, and the third was the painting viewed by Monsieur Monconys, which the baker may have purchased directly from the artist. In his dealings with the painter's widow, van Buyten proved to be quite generous: indeed, he allowed her twelve years to pay back the sum owed him in order

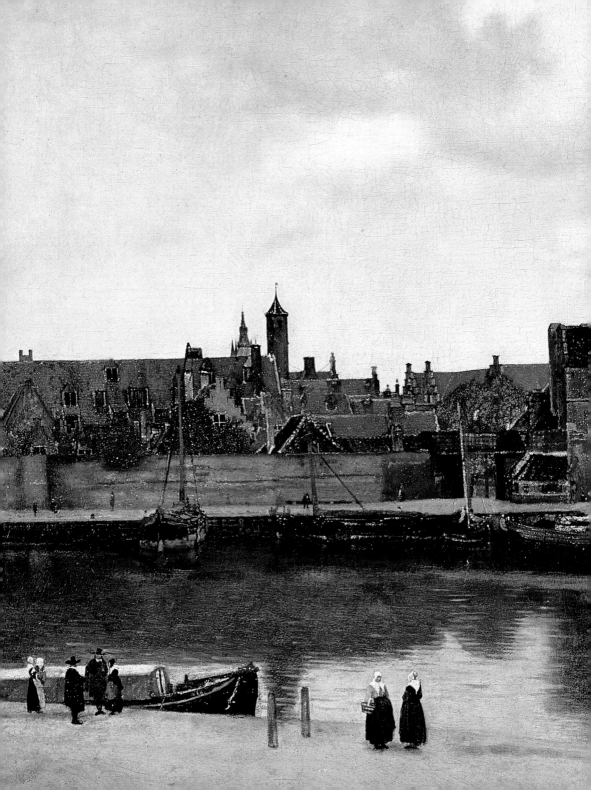

to get back her paintings, and in some indirect way, this may show the esteem and consideration the baker felt for Vermeer and his art.

Among the creditors who sought their due from Catharina after her husband's death was Jannetje Stevens, who traded in woolen cloths. She, too, was repaid in works of art: the merchant Jan Coelenbier of Haarlem carted away on her behalf twenty-six paintings that had belonged to the artist, with the intention of selling them. The auction that Coelenbier organized was held in 1677; in the announcement, one of the paintings listed for sale was *The Art of Painting*, which Maria Thins had claimed as her own. Given the low estimates for the works Catharina initially handed over to Jannetje Stevens, we can assume that there were no other canvases of Vermeer's, but rather the modest paintings that he traded in. The inventory of the widow's property drawn up in 1676 provides a rough idea of the worth of Vermeer's warehouse: the paintings listed totaled sixty-one,

and they included portraits of his forebears and some works by the artist's hand. Of the remaining paintings, only five were attributed to an author, so that the others must be assumed to have been simple things, low in value, suitable for decorating the homes of the middle and lower-middle classes of Delft. In the inventory of items found in his house, we can probably recognize some of the objects that Vermeer depicted in his paintings: nine leather chairs, a painting with a cupid, a satin jacket edged in fur, and an ebony cross.

The panorama of existing documents was reconstructed thanks to the studies of Michael Montias, but many aspects of Vermeer's artistic career are still unknown. Scholars have still not arrived at sure conclusions about his training and the identity of his teacher, nor about his youthful career or the attribution of certain works. The dating of the works, their destination and their meaning are all still under debate.

According to Montias, the painter learned to read and write in a local school. Then, still a child, he learned the rudiments of drawing and of mathematics from a neighbor, the Catholic painter Carnelis Daemen Rietwijck, who had a small academy on the Vodesgracht canal. Presumably, the actual apprenticeship —which, as required by Saint Luke's Guild, the painters' society, was to last six years— began sometime around 1644. In the absence of documents, the figures of the leading painters active in the period have been examined, seeking links with Vermeer's life history and his works. Both Montias and Arthur K. Wheelock, the author of the most recent catalogues, tend to think that Vermeer's training took place between Delft, Amsterdam and Utrecht.

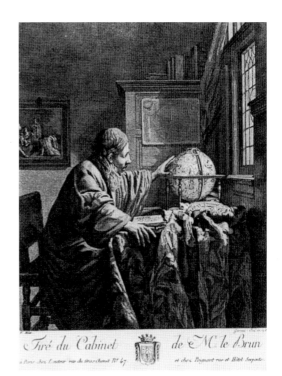

In his city of birth, scholars have ascertained contacts between the artist's father and two fairly successful painters: Evert van Aelst and Leonard Bramer. The former painted simple still lifes with fruit and

flowers, with elegant effects of light reflected on metallic surfaces. Bramer, instead, who, significantly, was among the witnesses present at Maria Thins's home on the evening of Vermeer's and Catharina's engagement, specialized in biblical scenes and mythological subjects. His style, influenced by the Italian Caravaggio and his followers, hinged upon strong lighting contrasts that earned him the nickname "Leonardo of the Night" in Rome. However, the frescoes he painted in the palaces of the Princes of Orange have been almost entirely lost. It appears that in these pictures, Bramer showed evidence of another mood, with monumental figures of a classical tang.

Between 1646 and 1649, Paulus Potter, a painter known for his representations of animals, also joined the Delft guild. His pictures are vivid and luminous and painted with extraordinarily realistic detail. For chronological reasons, however, we must agree with Montias that the intriguing hypothesis of Vermeer's apprenticeship with

Carel Fabritius must be excluded a priori; Fabritius was ten years older than Vermeer and settled in Delft in 1650. He did not join the painters' guild—which would have qualified him as master—until 1652, just fourteen months before Vermeer registered. Fabritius had been Rembrandt's pupil in Amsterdam, but he soon developed his own style marked by a great capacity for simplifying, the use of bright, rich colors applied in distinct, flat fields, and mastery of the rules of perspective. The monumental look of his figures, illuminated by natural light, contrasted with their small size. In the so-called *View of Delft* of 1652 (London, National Gallery), scholars explain the obvious distortion of the image and the disproportion between the foreground and the background by suggesting that Fabritius may have used optical instruments with special lenses. This extraordinary artist, the author of highly suggestive images, died in Delft in 1654, the victim of the tragic gunpowder arsenal explosion. His work

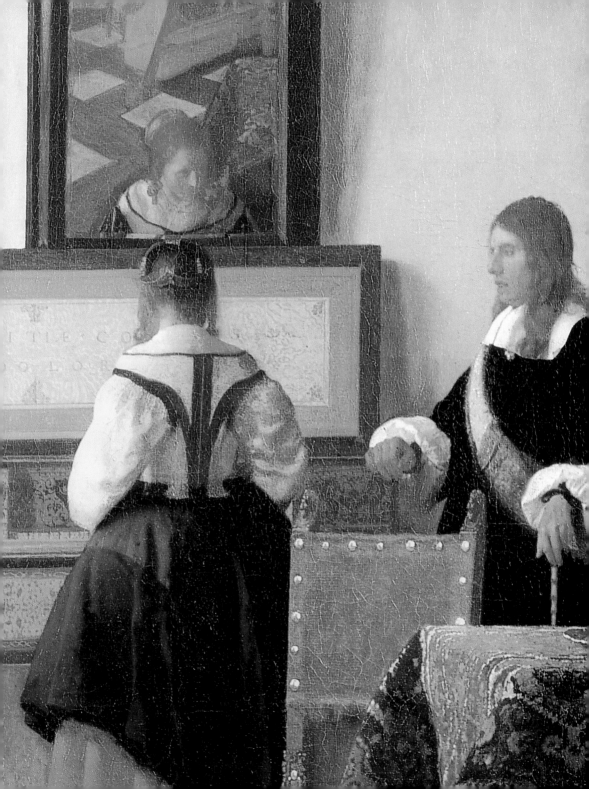

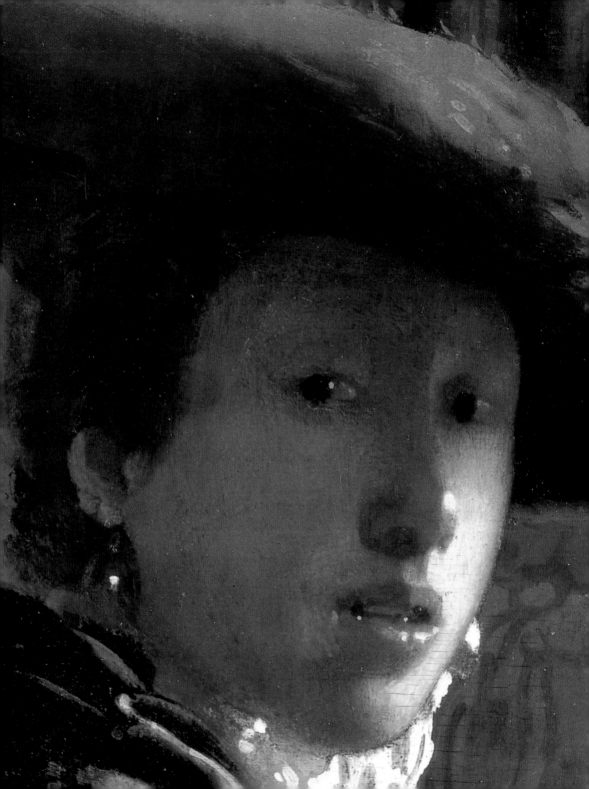

doubtlessly left a deep mark on the style of Vermeer, who, in fact, owned three of Fabritius's paintings, listed in the 1676 inventory; two of these paintings were studies of heads. Wheelock speculates that in one case Vermeer actually reused a panel that Fabritius had previously painted. According to the scholar, this would be proof that the two were indeed bound by a teacher-pupil relationship. The painting in question is the *Girl with the Red Hat* now in Washington, D.C. (National Gallery of Art), which many other scholars, however, believe is a fake. That Vermeer and Fabritius are mentioned together in a poem published in 1668 and known in two versions does not weaken Wheelock's argument; as a matter of fact, this poem describes how Vermeer arose from the fire of Fabritius and, according to the first version, followed in his path; in the second version, it says that Vermeer was able to emulate Fabritius, but in neither of the two is the relationship explicitly described as

the succession between master and pupil.

If Vermeer did carry out studies at Amsterdam and Utrecht, the Delft notary Willem de Langue may have played an important role in directing him toward these cities. An art connoisseur and collector, de Langue's relationship with Vermeer's father is well documented. The notary, who looked after the interests of a number of artists, including Bramer himself, was called on as witness to the drawing up of the deeds concerning Vermeer's engagement.

Critics have all but abandoned the old tradition that places Vermeer as apprentice in Rembrandt's shop in Amsterdam; at most, they seem willing to acknowledge the great master's distant influence in the artist's youthful works. Further ground has been gained by the possibility of training at Utrecht, where in the twenties, a Caravaggesque style developed, following the lead of Gerrit van Honthorst, known in Rome as "Gherardo delle Notti" (Gerard of the Night Scenes). Montias and Wheelock agree in suggesting

that Vermeer may have worked in the shop of the famous painter Abraham Bloemaert (1566–1651), who specialized in biblical and mythological scenes, portraits and still lifes. Bloemaert, an exponent of an elegant mannerism of a late sixteenth-century stamp, was a distant relation of Vermeer's future wife, Catharina Bolnes. Starting from the assumption that it is unlikely that the artist would have met his wife without the mediation of a common acquaintance, scholars give particular credence to the hypothesis that the elderly painter of Utrecht was one of Vermeer's masters; the fact that he was Catholic may have been a factor in the young artist's sudden and resolute conversion. During the period of his preparation, Vermeer may also have come into contact with Gerard ter Borch (1617–1681), a painter originally from Zwolle who traveled widely in Europe before settling once again in 1649 in his native Holland. On April 22, 1653, together with Vermeer, ter Borch acted as witness to the stipulation of a deed by the notary de Langue. The event took place only two days after Vermeer's marriage, and according to Montias, it would not be farfetched to imagine that ter Borch had traveled to Delft for the ceremony. Comparing his genre works with the paintings attributed to Vermeer's youthful period, the scholar in any case excludes that he could have been the young artist's master.

In effect, no hypothesis concerning the identity of Vermeer's master or masters can go without a comparison of his first known works and a subsequent study of possible stylistic influences. Wheelock ascribes three paintings to the early years of the artist's career: *Saint Praxedes*, *Christ in the House of Martha and Mary*, and *Diana and Her Companions*. These are three controversial paintings, since they clearly have nothing to do with Vermeer's mature style, but, to be precise, that of the mid-1660s. The three canvases, to begin with, depict historical subjects: a saint connected

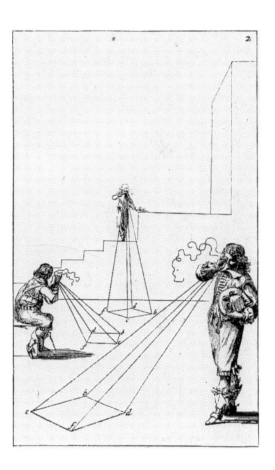

with the antique worship of martyrs, a scene
from the Gospels and one of a mytholog-
ical subject, all motifs that do not again
appear in the artist's work. Moreover, the
treatment of these themes is unrelated to the
painter's later style: the figures are imposing
and take up nearly the entire surface of the
canvas, leaving little room to describe the
setting and the background. Though from
a formal point of view the paintings are
consistent between themselves, the italian-
izing style and even the color palette do not
seem in line with the realism and the bright
tones of the most famous paintings. It has
been pointed out, in any case, how the rapt
expression of the protagonists is the way
Vermeer tended to portray his subjects. An
attempt to trace the path of the artist's
conversion has also been made, proposing
that the painting of Saint Praxedes was
commissioned by the Delft Jesuits, with
whom Maria Thins seems to have had priv-
ileged relations. *Christ in the House of
Martha and Mary* also offers clues for an

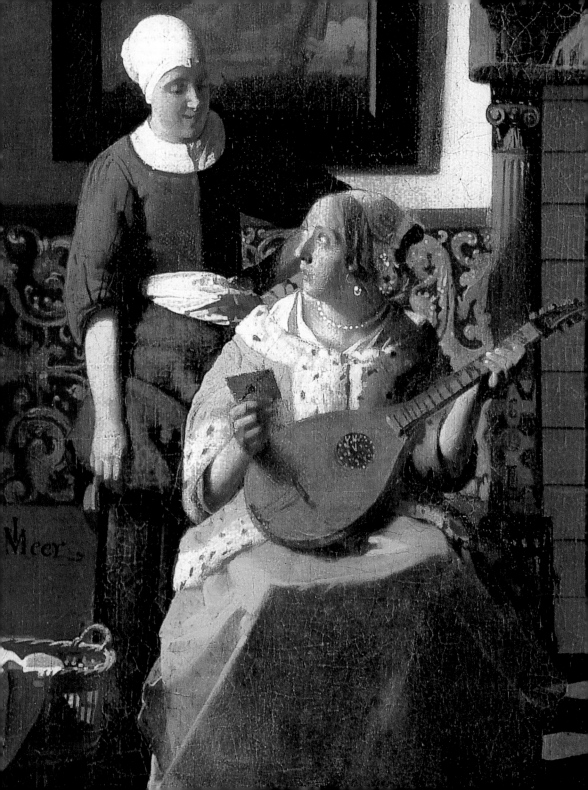

interpretation of the episode according to the Catholic doctrine: the close tie that the three figures seem to share could imply that faith (represented by Mary) must be reconciled with good deeds and works of mercy (Martha), in order to guarantee eternal life to whomever believes. The theme of *Diana and Her Companions* has also been traced back to Christian spirituality. Wheelock, in fact, sees in the act of the girl washing the feet of the goddess a foreshadowing of the same act performed by Mary Magdalene on Christ, and by Christ himself before the Last Supper. Two additional elements bring to mind the theme of the Passion: the thistle in the foreground, biblical symbol of tribulation and suffering, and the gesture with which the nymph in the background seems to be pulling a thorn from her foot. Her attitude recalls that of the Hellenistic statue known as *Spinario*, the thorn-puller, perhaps known to the artist through etched copies.

An analysis of the three paintings shows the author's familiarity with Italian painting,

here faithfully copied (as in the case of *Saint Praxedes*, taken from an original by the Florentine artist Felice Ficherelli), there simply echoed. In the past, this fact, along with other considerations of a stylistic order, led scholars to believe that the signatures on the three canvases referred to another artist, thus clearing the impasse created by comparison with Vermeer's later output: the author could have been Johan van der Meer of Utrecht (1630–1688), who also made the journey to Italy sometime around 1655. But the Delft Vermeer also could have studied and copied works of Italian art; it is hard to believe that there could have been any in Delft, but Amsterdam certainly represented a large market.

This reconstruction of Vermeer's youthful period gained currency toward the close of the nineteenth century, with the discovery of his signature on the canvas of *Diana and Her Companions*, which until then had been believed the work of Nicolaes Maes. The other two attributions came as a

result: the last in order of time, that of *Saint Praxedes*, was not formulated until 1986. Notwithstanding the differences pointed out, there is a certain continuity that links these paintings to the first one that nearly all critics accept as Vermeer's, *The Procuress*, and thence to later works through a long stylistic itinerary marked by progressive developments. *The Procuress*, dated 1656, seems to be Vermeer's first genre painting; in this scene of everyday life, however, the artist probably meant to depict another episode of the New Testament, that is, the prodigal son who squanders his inheritance in a tavern. Thus, to discover the first painting to show a theme more in line with the later poetics of the artist, we must go as far as *A Maid Asleep*, where for the first time a hushed middle class interior is depicted.

If we accept the paintings of the youthful period, we see how it was not until 1657 that Vermeer arrived at his preferred genre, three years after he joined the painters' guild.

The typical traits of his style, in particular the preference for a bright, luminous color range, only gradually emerged. The new orientation reflected trends popular among Delft painters, who in the meantime had changed. Starting from 1650, a new kind of painting had become widespread, focusing on architectural subjects: these paintings depict church interiors occupied by small, dignified figures and illuminated by natural light that filtered through the windows. The authors of these paintings favored unusual vantage points and diagonal perspectives that imbued their works with a powerful emotional charge. The most famous among these painters was Emanuel de Witte, who was born around 1617, and had already left the city by 1653.

In 1654, the famous painter Jan Steen rented an alehouse in Delft; he probably never resided in a stable manner in Vermeer's town, and he certainly never joined the local guild, but his style may have exerted a decisive influence in the defini-

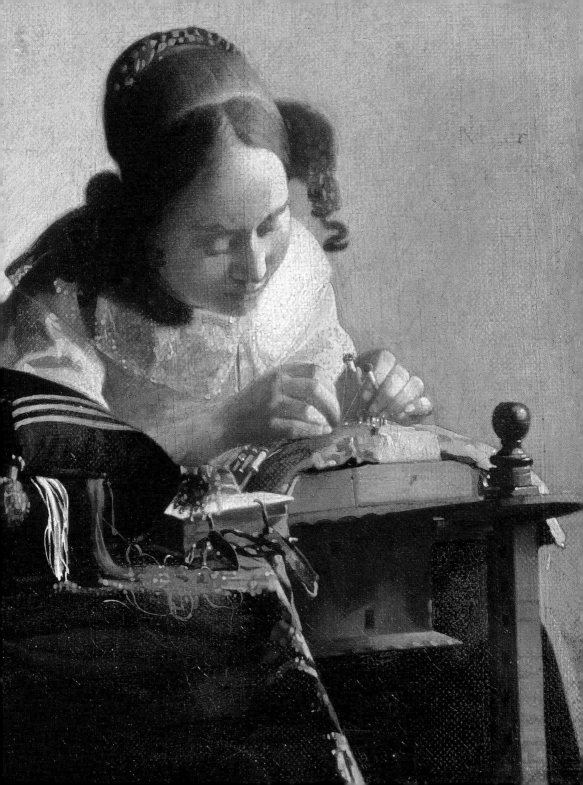

tion of a new trend in art. Steen, who did historical as well as genre paintings, set his everyday life scenes in balanced, harmonious compositions, illuminated by natural light and rich in carefully observed details. In the same year as Steen, Pieter de Hooch arrived in Delft from Rotterdam, and he joined the guild in 1655. During this period, he painted interiors and courtyards of middle-class homes, giving particular attention to the effects of sunlight and perspective construction. Beginning in 1657, in many of Vermeer's paintings there are precise references (not just thematic) to de Hooch's works. For example, in *Girl with a Glass of Wine*, the composition recalls precisely de Hooch's *Girl Drinking with Two Soldiers* (1658, Paris, Musée du Louvre). Though the two artists must have known each other, it is difficult to establish who influenced whom, since even de Hooch's style seems to have developed in the Delft milieu. They probably kept in touch even after de Hooch left Delft for Amsterdam, toward the close of the fifties. In the *Love Letter* (Amsterdam, Rijksmuseum), Vermeer used the compositional device of the series of rooms for the first time in his own paintings and inspired by de Hooch's paintings dating around 1668.

The interiors Vermeer painted display an extraordinary stylistic unity marked by a rigorous application of the rules of perspective and a balanced arrangement of carefully selected individual elements. Some features typical of his compositions persist: for example, the lighting from the left, filtering through a window, and the setting for the scene in the corner of a room, which enhances the sense of intimacy. There is also the presence in the foreground of an element that acts as a barrier and separates the viewer from the figures depicted. This has the same function: most of the time, it is a table with a cover, or a chair or a brocade curtain gathered to one side. The framing elements are always chosen according to rigorous criteria: there are no figures extraneous to the action represented, such as the

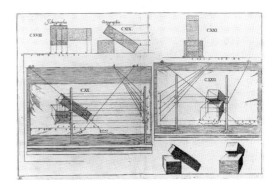

servants or the pet dogs that can be seen in so many domestic interiors of other Dutch masters. In the description of the rooms, the choice of objects is just as severe: both furnishings and decorations are reduced to the essential, often limited to geographical maps and paintings barely sketched in the background, or to small scraps of still life with crockery or musical instruments. Light seems to be one of Vermeer's primary areas of interest: the artist describes its incidence on objects and on the figures; he observes its reflections on materials and colors; he uses technical details to render effects of natural perception. In his paintings, the shadows are never black, but always a tone of color darker than that of the illuminated areas. Often the light reflects the shade of the objects it falls on, and projects them on the interior. This is the case, for example, in *Woman in Blue Reading a Letter*, where the wall in the background takes on delicate bluish shades. Also, in defining the outlines of objects, Vermeer seeks to reproduce the

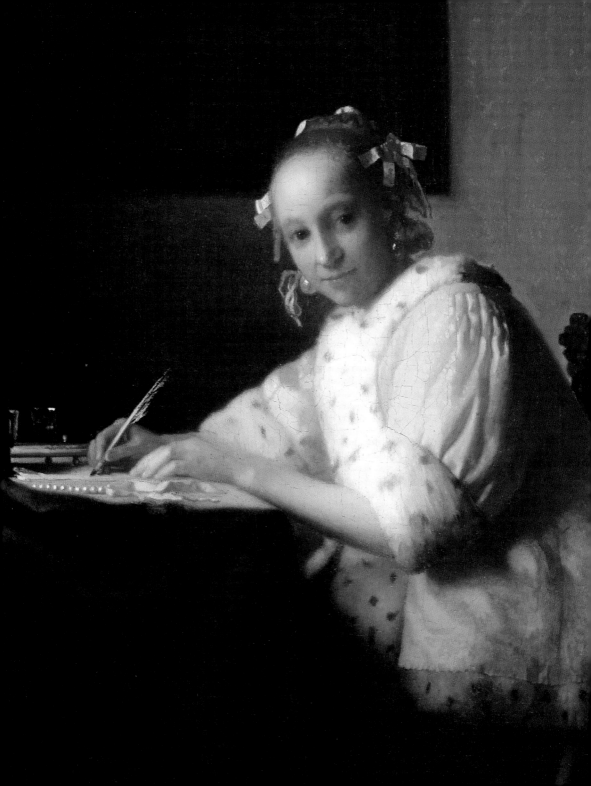

soft tones of a diffused light, juxtaposing pigments and blending them with delicate strokes of the paintbrush: thus, his figures are never drawn with precise outlines, but rather with imperceptible contours that accentuate their luminosity.

Though well aware of the rendering of the surfaces and the texture of different materials, Vermeer was never a "fine master" in the sense this term takes on in the Dutch tradition. Gerrit Dou and Frans van Mieris, who, instead, well represent this tendency, painted with fine brushes, proceeding with great precision and patience to define every detail. Vermeer preferred a more synthetic method, where visible strokes delineate the objects in a summary manner. In this respect, an unusual facet was his "specks of color" technique, often described with obvious license as "puntinism" or "pointillism." The procedure consists in emphasizing highlights on surfaces by means of drops of pure color, thick brushstrokes that stay in relief on the canvas surface. This style, especially evident in the paintings of the late 1650s, may disclose distant origins in the work of Rembrandt: in fact, the master often used thickly applied pigment, taking full advantage of the expressive capacity of paint and the refraction of light. Vermeer's use, too, of globs of color was to great effect; for example, in the still life in the foreground of *The Milkmaid*, the specks seem to reproduce the rough surface of the bread, the weave of the wicker basket, and the uneven texture of the bronze. The same technique can be found in a work of the artist's late maturity, the famous *Lacemaker*: here, the golden tassels of the sewing cushion, suggested by the juxtaposition of the highlights.

Such conditions make it rather difficult to establish with certainty a chronological order for Vermeer's paintings, all the more so since only two of them are dated, that is, *The Procuress*, 1656 and *The Astronomer*, 1668. Scholars have nearly unanimously agreed upon a line of development in his

style, grouping works on the basis of complex considerations about similarities and differences: the procedure is quite obvious, for example, with the single-figure paintings of the early 1660s, beginning with *Woman in Blue Reading a Letter* and ending with *A Lady Writing*. The greatest difficulty lies in formulating a precise dating for each piece; the critics usually differ in their opinions, and they often opt to indicate a range of years, a solution that permits them to relate the work to others that they consider closest in time. On the whole, a gradual weakening can be observed in the paintings of Vermeer's maturity: the stylistic unity becomes mannerism and some of the typical qualities bit by bit fade away. The process is obvious in the paintings of the 1670s, where the diffused light and the blurred outlines give way to a cold and obdurate radiance that clearly defines the figures' shadows and profiles. The development is accompanied by a progressive refinement of the subjects, as if the technical decisions are determined

by thematic ones: the painter abandons such popular images as *Officer and Laughing Girl*, and *The Milkmaid*, to arrive, in *The Love Letter*, at a description of an elegant, almost ostentatious interior.

Vermeer's stylistic evolution, after all, coincides with the appearance of a new style in Dutch art: in about 1660, in response to changes in customers' tastes, a painting of an international flavor emerged, in tune with the elegant academic classicism first theorized by Gérard de Lairess (1640–1711).

The choice of subjects and the faithful rendering of three-dimensional space, natural light and the appearance of different materials place Vermeer's painting squarely among the finest examples of the realism typical of seventeenth-century Dutch art.

To show depth and the relationship of size between objects, Dutch artists essentially took as their basis the rules of central perspective; however, they also used a series of instruments and technical aids that facili-

following pages
The Astronomer
(detail), 1668
Paris, Musée du Louvre

tated their job and deepened their knowledge about representing space. For example, there were glass screens that made it possible to transfer onto a small surface the exact proportions of a very broad view, or lenses and optical devices that made it possible to observe the articulation in depth of planes and the relative effects of lighting and color. Often these devices made it possible to achieve distortions of value for expressive aims: this, for example, is the case with the painting by Carel Fabritius, mentioned above, *View of Delft*, which seems to have been taken by a wide-angle lens. Another instrument used was the camera obscura, rooms, or more simply, boxes, which, based on the fundamental principles of refraction, made it possible to project a three-dimensional object onto a flat surface.

It is not possible to prove that Vermeer used any of these means, but some obvious formal factors in his paintings suggest that he took advantage of optical instruments. For example, in *Officer and Laughing Girl*, the clear disproportion between the foreground and the background seems to derive from the use of a lens, through which the man's elbow and the brim of his hat seem to be projected toward the observer. The effect is similar to that of Fabritius's view. The technique of the specks of color, too, could imply a relationship with optical effects achieved through lenses: if, in a camera obscura the image in the foreground is allowed to get out of focus, in fact, the most luminous areas appear as soft halos, just as they do in Vermeer's paintings. The painting most representative in this respect is *The Lacemaker*, where the framing, the articulation of the planes, and the handling of the objects closest to the observer all reproduce the view through a lens focused on the figure of the protagonist.

In any case, it is safe to say that Vermeer's use of optical instruments did not necessarily mean that he faithfully copied the visual data he so obtained: indeed, we need not think that the artist copied in any

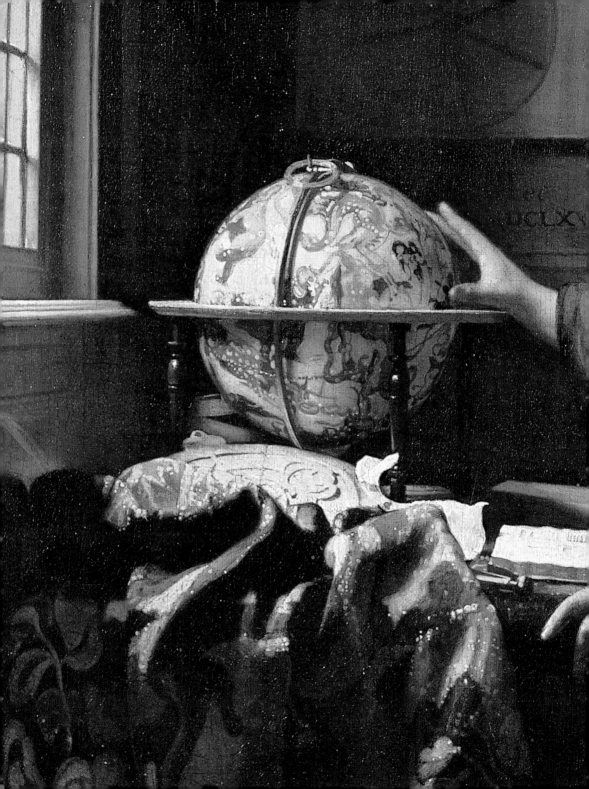

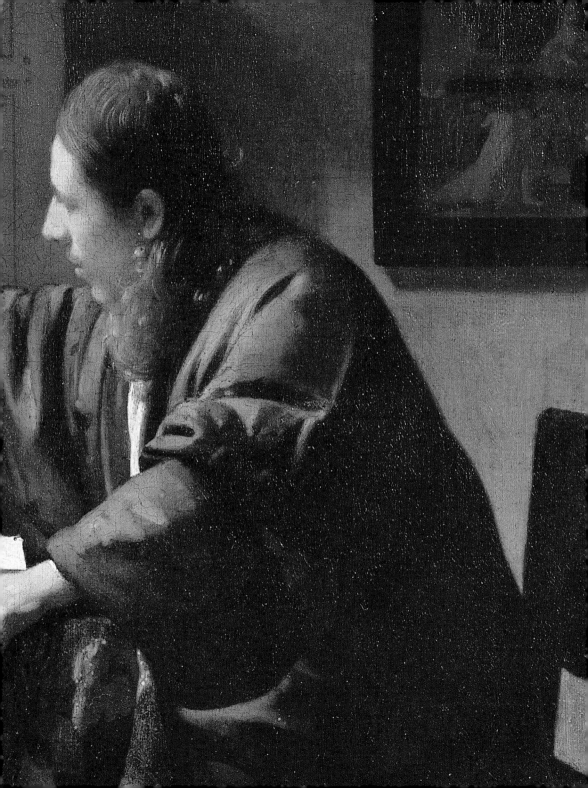

way the images projected in a camera obscura, but that observation through these devices served him simply as inspiration. The procedure is obvious in the *View of Delft*, the very subject and panoramic angle of which suggest the use of lenses and projection screens. Scholars have demonstrated that in reproducing a truly existing part of the city, Vermeer modified the real data to achieve a precise stylistic effect: he simplified and redistributed the volumes of the buildings to get a sort of horizontal frieze, offset by the vastness of the cloudy sky. In Vermeer's paintings in general, the displacement of the vanishing point, the horizon line and the main elements of the composition always came in the wake of a careful geometric calculation, often in function of the artist's expressive needs. In *Lady Writing a Letter with Her Maid*, which hinges entirely on the contrast between the emotional tension of the woman and the placid serenity of the maid, there is an obvious link between the construction of the perspective and the meaning. The orthogonal lines that radiate from the window frame lead the observer's gaze to the eyes and the folded arms of the maid; then the gaze swerves to the lady's frowning face and her right shoulder, which is slightly raised as she writes.

Vermeer's precision in reproducing musical instruments, geographic maps, and globes are often pointed out as proof of his realism. All these objects were made by the most learned and sophisticated of Dutch and Flemish craftsmen, and they could be found in high-class homes as articles both for personal use and for show. This is the case, for example, with the virginals Vermeer depicted in more than one of his paintings, carefully describing their contours and decorations. As far as the maps are concerned, the precise subjects are easily recognizable and can be traced back to examples still existing today of prints made in his time. Once again, the artist transcended the simple, real aspects,

modifying them to conform to his expressive needs. One of the most obvious examples of this is *Woman in Blue Reading a Letter*, where the geographical map in the background is the same as the one in *Officer and Laughing Girl*: in the two versions, the colors and the size of the map change, since the two scenes have quite different compositional features.

The fact that in Vermeer's works, apart from circumstantial variations, it is easy to find recurrent objects and places has led scholars to think that they were part of his everyday life. Thus, we can imagine that his atelier was a room with diagonal black-and-white tiling and that the room took light from one or more windows with leaded glass, placed to the painter's left. It seems that the chairs with leonine finials, upholstered in two different ways, can be recognized as those listed in the inventory of his property; the same goes for the yellow jacket with fur edging often worn by his models. However, the same cannot be said for the carpet and the brocade curtains that in a few variations appear in several paintings. Some of the paintings Vermeer depicted on the walls of his interiors can also be traced to the 1676 inventory. This is the case with Dirck van Baburen's *Procuress*, seen in two different paintings (*The Concert* and *A Young Woman Seated at a Virginal*). The work originally belonged to Maria Thins, who also owned other paintings that can be traced to the Utrecht school.

In 1976, an exhibition held at Amsterdam's Rijksmuseum proposed a new mode of interpretation for Dutch painting of the Golden Age: "apparent realism." According to the curator of the exhibition, Eric de Jongh, the comparison between genre paintings and the literary-figurative tradition of the symbols would lead to a reconsideration of widespread theories about the art of the Netherlands, traditionally held to be an accurate mirror of reality. The scholar maintained that behind the scenes

of everyday life are concealed moral, ethical, and symbolic connotations communicated through a visual language that for observers today is obscure, but for those of the time must have had clear and immediate significance. In fact, they were known through many popular books of symbols: collections of illustrations accompanied by mottos and comments that made the meanings clear. Understanding of these images did not always and necessarily require profound and sophisticated background: often the symbols were rooted in the popular imaginations of proverbs and sayings, and this made them all the more accessible.

The symbolistic interpretation has enjoyed great success among the most recent Vermeer studies. For some of his works, opportune references to known symbols have been discovered, and this has encouraged scholars to seek symbolic meanings in most of his genre works. In fact, it is acknowledged that certain iconographic typologies were associated with hidden meanings: for example, pictures of young women at the mirror, also present in Vermeer's œuvre, veiling allusions to themes of self-knowledge and the futility of earthly things. The so-called pictures-within-the-pictures often contribute to the definition of these meanings; for example, the *Last Judgment* in the background of the *Woman Holding a Balance*, interpreted as an invitation to weigh one's own deeds and act with temperance.

Sometimes the iconological interpretation of Vermeer's paintings is rather complex: this is the case with *Gentleman and Lady at the Virginal*, more commonly known as *The Music Lesson*. In this painting, a young woman is seen from the back as she plays the harpsichord, while a gentleman alongside her listens attentively; the girl's face is reflected in the mirror. A viola da gamba is abandoned next to them, seen behind a table. Various of the scene's elements seem inspired by two symbols illustrating the theme of love through refer-

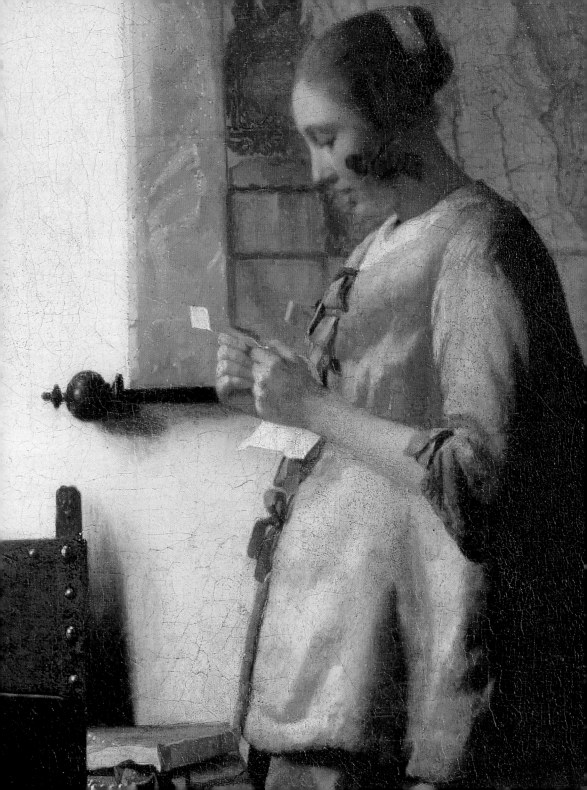

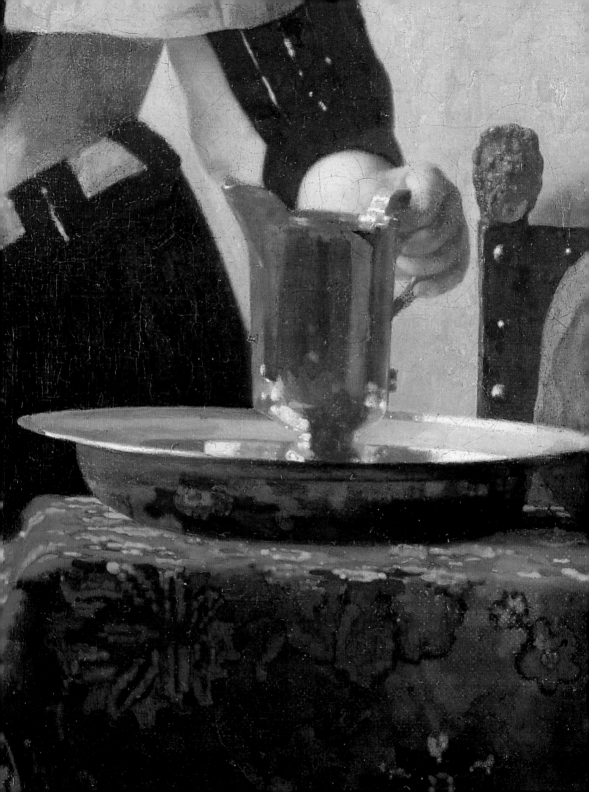

ences to the musical sphere. One of them, dated 1627, is the work of the celebrated painter Jacob Cats; in it, there is a man playing the lute with alongside him another instrument. The motto associated with this image is *Quid non sentit amor!* and the caption explains that the sound of an instrument resounds in the case of the one near, just as with the sentiments of lovers. In a table showing *Emblemata amatoria* of 1611, we find, instead, the theme of music associated in a romantic key with that of the mirror. In the foreground Cupid holds a mirror that reflects the sunlight, while in the background a lady plays the virginal in the presence of a gentleman. The caption reads, "It shines and makes all things shine." By drawing the simile between the harmony of music and the harmony of love, Vermeer aims to underscore the sentiment that joins the two figures, barely hinted at by their discrete gestures. The glimpse we get of the painting in the background makes it recognizable as one of those belonging to Maria Thins, portraying the so-called *Roman Charity*: the story is that of the aged Cimon, starving in prison, saved by his devoted daughter Pero, who nourishes him at her own breast. The metaphor thus acquires further meaning: love is a source of consolation and comfort, and this goes for music as well. On the cover of the virginal is inscribed the Latin motto, "Music: companion of joy and balm for sorrow."

Art historian Svetlana Alpers has challenged the emblematist reading of Dutch art, though she does not deny a link between the language of genre painting and that of popular images in emblem books. However, she maintains that the moralist meaning should be considered secondary with respect to the formal values of the art of Vermeer and his contemporaries. In their paintings, Alpers sees the absolute preeminence of the description, though interpreted in the light of keen references to the philosophy and science of the time.

According to a reliable calculation based on the relationship between the number of works that have come down to us and those mentioned by the sources, Vermeer painted somewhere between fifty and sixty paintings in the course of his entire career.

Documentary research has identified one other possible customer of Vermeer's, in addition to the baker van Buyten. There is no direct information about the exact nature of his relationship with the artist: this absence is all the more critical as it seems to concern a figure more like a patron than an occasional buyer. This Maecenas was the rich Delft landowner and collector, Pieter van Ruijven, some years older than the artist. In 1657, he lent to Vermeer a small sum that was recorded in a notary deed; it is believed to be money "up front" for the execution of some paintings, and that his relationship with the artist continued on a rather close basis in the following years. In fact, in 1665, his wife declared in her will her desire to leave to Vermeer a small sum. The ties between the two families are confirmed by the fact that in 1670, the nobleman was in the home of Gertruy Vermeer, the artist's sister, as witness to the drawing up of her last will and testament. Van Ruijven died in 1674, followed just a few years later by his wife Magdalena. All the family's assets, including an valuable painting collection, were inherited by the son-in-law, Jacob Dissius, who, before his marriage, had been a propertyless bookbinder. In 1683, the year after Magdalena van Ruijven's death, an inventory of Dissius's property shows that he owned, among other things, twenty paintings by Vermeer, the subjects of which, however, are not listed. Jacob died in 1695, and the following year the paintings in the collection were put up for auction in Amsterdam. The auction announcement lists and describes twenty-one works by Vermeer, one more than in 1683. Among them are some of the masterpieces of the second half of the 1650s, such as *The Little Street* and *The Milkmaid*; in the list we can also positively identify

Woman Holding a Balance, *View of Delft*, and several others. The documents do not allow attributing to Pieter van Ruijven the credit and the responsibility for all the purchases. For example, it seems possible to reconstruct that at the moment of his death *Woman with a Pearl Necklace* was still in Vermeer's studio, and that it became part of the collection only after 1675. In any case, it must be acknowledged that the collection owned by van Ruijven-Dissius shows characteristics of extraordinary interest, not only in terms of quantity. In fact, it seems possible to detect the fruit of an ongoing relationship of trust with Vermeer.

Tradition holds that the scientist Antony van Leeuwenhoek, mentioned above for his role as administrator of the bankruptcy of the artist's widow, may have figured among Vermeer's customers. The intriguing hypothesis arises from the need to explain the existence of two rather unusual paintings within the context of the output of Vermeer, who loved to paint feminine figures busy with

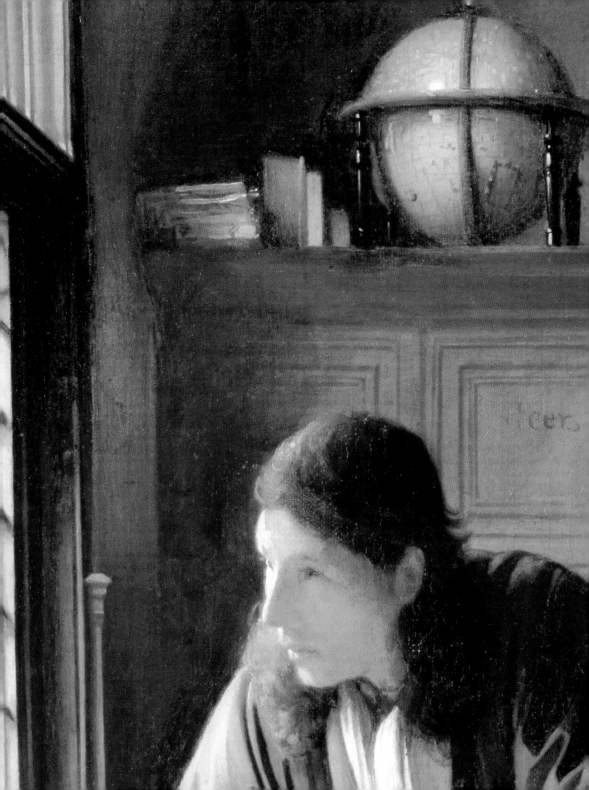

simple everyday activities. The paintings are *The Astronomer* and *The Geographer*, and they feature male protagonists, scientists shown with the instruments of their work. Thus, it was only natural to imagine a patron with a specific interest in this sort of subject. It was thought that these were two portraits of the same person, to seek among the Dutch intellectuals of the time. Leeuwenhoek, famous for his microscope research, was a contemporary of Vermeer's, and he dabbled in astronomy as well. In 1669, soon after the two paintings had been made Leeuwenhoek took an examination in topography; presumably, he shared an interest in lenses and optical instruments with the painter, and the two were joined by a bond of friendship. The idea that who commissioned (or who was portrayed in) the two portraits was the illustrious scientist is quite interesting, but not supported by sure documents.

The most important eighteenth-century source for Dutch art history, the three volumes dedicated by Arnold Houbraken to the lives of the painters (1718–1721), barely mentions Johannes Vermeer. Such scant attention can probably be explained by the fact that at that time, Delft had lost any importance from an artistic point of view: there was no longer an interesting local school of painting, and the only activity worthy of note was the famous production of majolicas. In any case, beginning with the 1696 auction and for all the of eighteenth century, Vermeer's works circulated on the antiques market, enjoying esteem and fair prices. Sometimes, however, there was confusion in the attributions: the Delft artist was mixed up with others possessing his same name, and his works were even attributed to such other artists specialized in interiors as de Hooch, Metsu, and van Mieris.

In 1822, at a sale held in Amsterdam, William I purchased the *View of Delft* for the Mauritshuis royal picture gallery, paying a significant price. The sovereign went on with his undertaking, even though the collection director of the time showed little interest.

Perhaps this can be explained by the bond his family had with Vermeer's city, which held the tombs of the House of Orange. The purchase was warmly supported by the director of the Rijksmuseum at the time, Cornelis Apostool. The public showing of this extraordinary painting brought Vermeer to the attention of scholars. In particular, the French critic Théophile Thoré, also known by his pseudonym Willem Bürger, dedicated three short, enthusiastic essays to the painter published in *Gazette des Beaux-Arts* in 1866; for this reason, he is commonly considered Vermeer's discoverer. The growing appreciation for Vermeer's work went hand in hand with the emerging trends in French painting of the time: the attention to themes from everyday middle-class life and the formal experiments with light, color, and the brushstroke. Wonderful, brilliant pages on Vermeer's painting turned up in Marcel Proust's *In Search of Lost Time*; the writer evidently perceived a strong spiritual affinity with the painter, who became his favorite artist.

Powered by this renewed interest, attributions to Vermeer proliferated to the point of excess, receiving confirmation from the scholars themselves, and including the works of many other masters. The critics' interest was matched by market activity, both in Europe and in the United States. Between the close of the nineteenth century and the start of the twentieth a number of fakes were probably created, constructed by putting together elements copied from authentic paintings. The most sensational forgery case was the one discovered in 1945 of a Dutch painter, Han van Meegeren (1889–1947). In the period just after the war, the artist was accused of collaborating with the enemy: found among the Nazi war treasures was a *Christ and the Adulteress*, supposedly by Vermeer, that van Meegeren had sold to Reichsmarschall Hermann Göring. Suspected of having given Dutch works of art to the enemy, van Meegeren defended himself saying that they were fakes he himself had made: to demonstrate his skill, he painted

while under house arrest a *Christ Among the Doctors* in what was then believed to be the style of the young Vermeer. It was discovered that a *Supper at Emmaus* of his had been bought by the Boijmans Van Beuningen Museum in Rotterdam. The forger was condemned to one year of prison and ordered to compensate the Dutch state and the other defrauded collectors. Van Meegeren did not serve his entire sentence; he died of a heart attack soon after his trial. The success of his scheme depended on the scant knowledge there was at the time of Vermeer's early style: van Meegeren's paintings today appear to us as clumsy and improbable.

In the early twentieth century scholars' main efforts were directed to identify Vermeer's corpus of work, eliminating all those that had previously been wrongly attributed to him: Lawrence Gowing, Albert Blankert and Arthur K. Wheelock, who still do not agree in some cases, have contributed over the years to a correct reconstruction of the artistic figure of Johannes Vermeer.

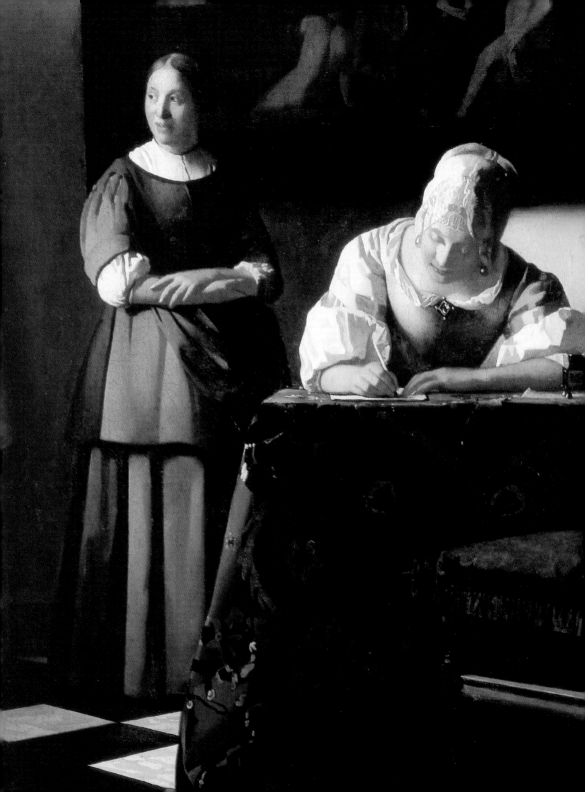

The Masterpieces

Saint Praxedes

1655
Oil on canvas, 101.6 × 82.6 cm
Princeton, Barbara Piasecka
Johnson Collection
Signed "Meer 1655" and
"Meer N R [..]o[.]o

The current state of our knowledge leads us to assume that this is the first of Johannes Vermeer's known works. The painting surfaced at an auction in 1943, and is now part of a private collection. In 1969 it was exhibited in New York and was attributed to a Tuscan artist, even though the signature, "Meer 1655," had already been identified. The attribution to Vermeer is, therefore, recent, and not universally accepted. It is primarily based on the inscriptions, and then on the stylistic affinities with *Christ in the House of Martha and Mary* and *Diana and Her Companions*, in their turn, also hotly debated.

Saint Praxedes was a Christian who lived during the period of persecution. In paintings she is shown wiping the blood of the martyrs with a sponge to conserve it as a relic. For the painting attributed to Vermeer, a precise Italian model has been identified, the work of the baroque painter Felice Ficherelli called *Riposo* (c. 1605). Ficherelli was active in Florence and specialized in scenes with martyrs. The second inscription of the painting could refer to him and has been interpreted as "Meer after Riposo." Indeed, Vermeer faithfully copied this *Saint Praxedes*, now in a private collection at Ferrara; the most important change is a crucifix held by the saint in the Dutch work that does not appear in the Italian one. Critics have interpreted this detail as a confirmation of his committed conversion to the Catholic doctrine in the years just after his marriage.

The identification of a precise Italian model for this work corroborates the evaluations expressed by most critics about Vermeer's early output, the style of which already had been described as italianizing. It is safe to think that after a phase of making faithful copies, of which the *Saint Praxedes* would be one, the artist started to imitate more freely the style of his models, as can be seen in the *Christ in the House of Martha and Mary*, and, in particular, in *Diana and Her Companions*.

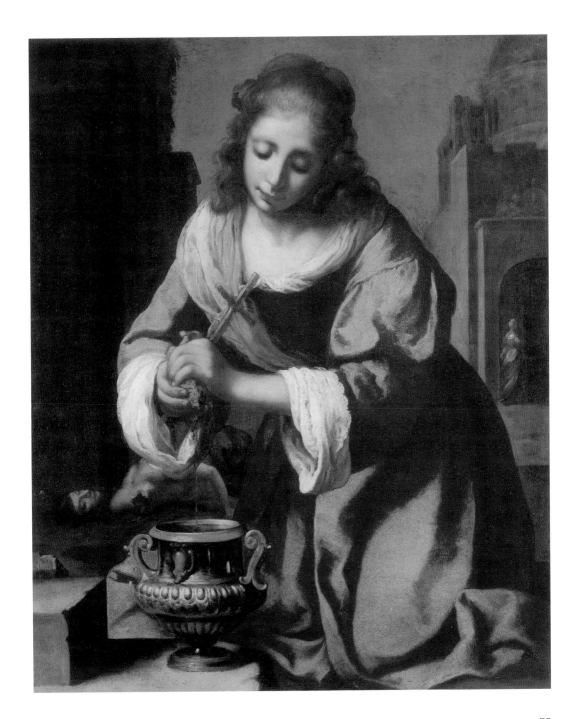

Christ in the House of Martha and Mary

c. 1655

Oil on canvas, 160 × 142 cm
Edinburgh, National Gallery
of Scotland
Signed "IVMeer"

The presence of the signature that prompted the attribution of this painting to Johannes Vermeer was revealed by restoration carried out in 1901 when the painting was in the hands of two London art dealers. Since then, *Christ in the House of Martha and Mary* has been a fundamental point of reference for the reconstruction of the artist's early style; however, the autograph on this painting is not universally recognized as authentic.

The episode illustrated is Christ's visit to the house of Martha and Mary; the Gospels tell how while Martha was busy preparing to welcome the guest, her sister Mary sat near Jesus listening to him with devotion. Bothered that Mary was not helping her, Martha turned to Jesus; he told her not to worry, as Mary's decision to listen to him was "the one thing [...] needful" (Luke 10, 38:42). The theme is that of the contrast between active life (Martha) and contemplative life (Mary), between worldly goods and spiritual goods. In the iconographic tradition, this subject was a pretext for painting kitchen scenes, with generous passages of still life. Vermeer, instead, reduced the setting to a minimum, and limited his depiction of food to a single basket of bread; this reference to the theme of the Eucharist allows a different evaluation of the meaning of the painting. According to Catholic doctrine, in fact, salvation is not obtained by faith (Mary) alone, but also by good and merciful deeds (Martha): this would explain the attitude of intimacy between the three figures.

The size of the painting, the imposing stature of the figures, the execution technique, the ochre hues of the background and the italianizing Christ-type are rather far from Vermeer's mature output. The closest stylistic reference for this work can be found in two painters of the Utrecht school, Hendrick ter Brugghen and Abraham Bloemaert.

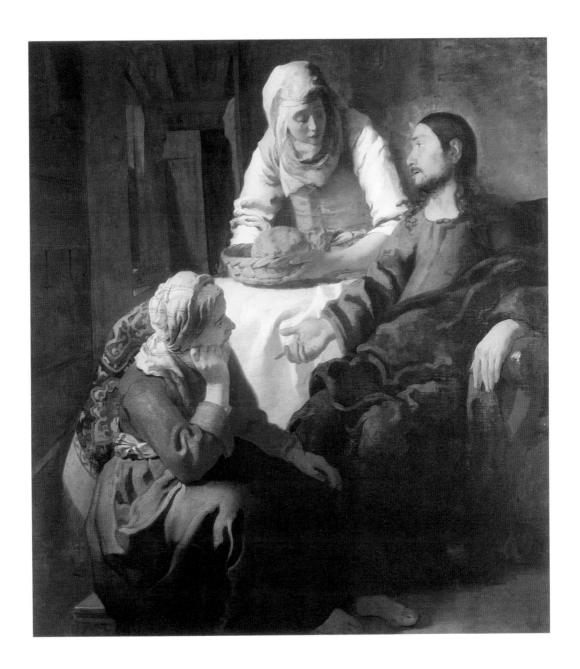

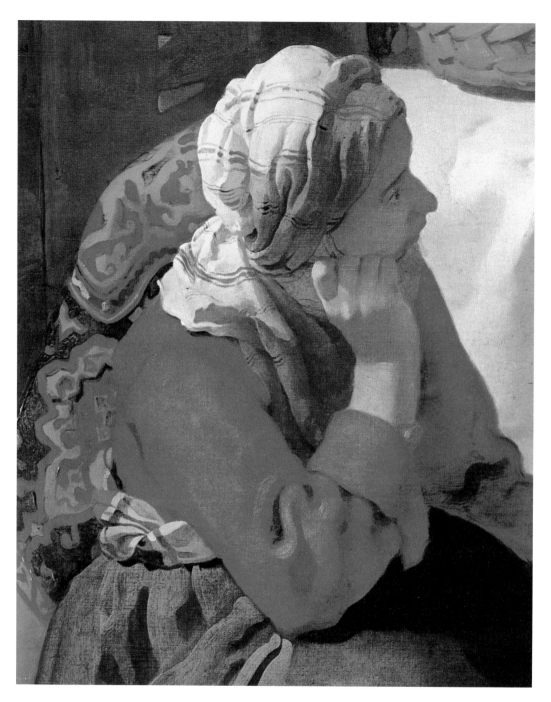

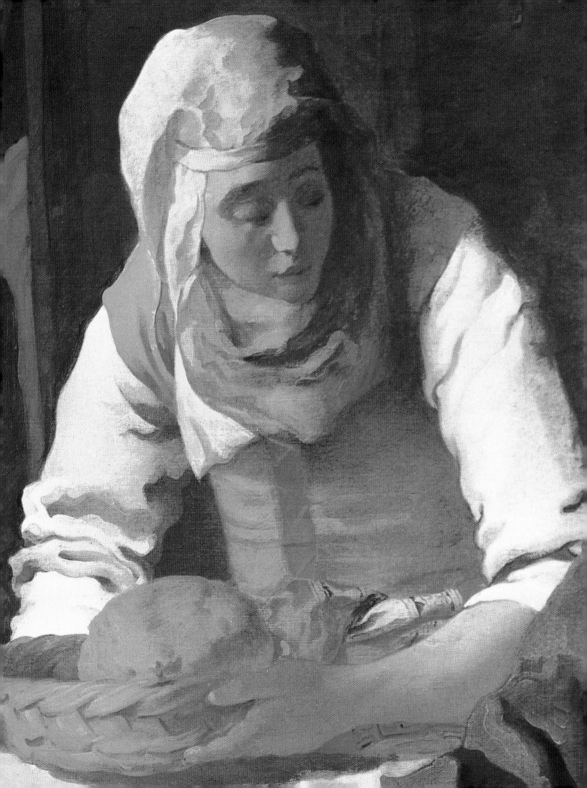

Diana and Her Companions

c. 1655

Oil on canvas, 97.8 × 104.6 cm
The Hague, Koninklijk
Kabinet van Schilderijen,
Mauritshuis
Signed "JVMeer"

In 1876 *Diana and Her Companions* was bought for the Mauritshuis at a Paris auction, where it appeared as the work of Rembrandt's pupil, Nicolaes Maes. The comparison with *Christ in the House of Martha and Mary* and study of the signature later suggested that it could be an early work of Vermeer's. This attribution is controversial, as are all those concerning the paintings of his early career.

The subject of the painting makes no reference to any particular episode of the myth of Diana, who is simply shown in a landscape together with some of her companions. The goddess seems to be lost in thought as one of the nymphs bathes her feet. There are no elements alluding to her nature as hunter, it seems rather that the painter meant to show her as a goddess of the night. The only clear attribution given is the crescent moon decorating her head. The warm, golden light suggests that the scene is taking place around dusk. The melancholy atmosphere is heightened by the poses of the figures, absorbed and introverted; their gazes are downcast and the face of the protagonist is in shade. For this reason, a symbolic reading has been proposed for this work based on the association between night and death, or on a Christological interpretation. Among other things, there are links with the Christian theme of foot-washing, represented here with a solemnity foreign to the tradition of mythological paintings.

From an iconographic point of view, the work makes strong references to a painting by Jacob van Loo (Berlin, Staatliche Museen), who in those years was one of the leading painters in Amsterdam. Some stylistic devices and the painting technique with thick impasto suggest significant parallels with Rembrandt: the position and the absorbed attitude of the goddess recall the *Bathsheba* at the Louvre, dated 1654. Finally, the light and the figures have Italian origins. The chromatic similarities with *The Procuress* suggest a dating of about 1556.

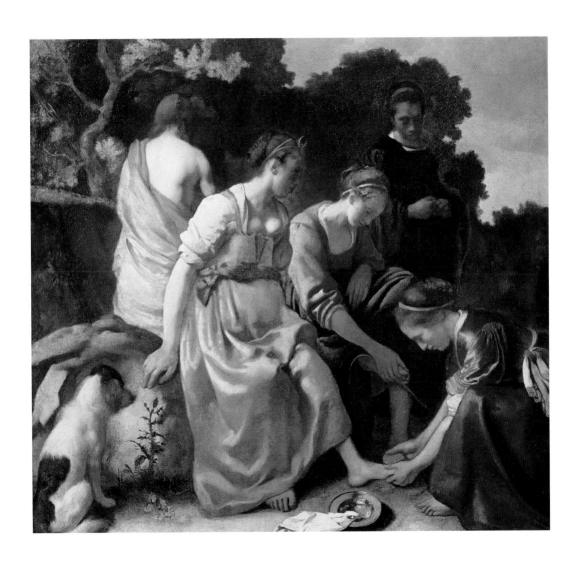

81

The Procuress

1656
Oil on canvas, 143 × 130 cm
Dresden, Gemäldegalerie
Alte Meister
Signed "IVMeer. 1656."

The painting was purchased for the Dresden collection in 1741. In the inventories following this year, there are inconsistencies concerning the precise identity of its author, who is said to have hailed from Haarlem, then from Utrecht, and finally, from Delft. The attribution to Johannes Vermeer of Delft was formulated already by the first scholars of the artist, and is nearly unanimous. Being signed and dated, this painting represents a crucial point of reference for the dating of the other early works and those of the first maturity.

Despite the title by which this painting is conventionally known, scholars tend to see *The Procuress* as a picture inspired by the New Testament; it shows, in fact, an episode of the Prodigal Son story, to be precise when the youth squanders his inheritance in a tavern, in the company of prostitutes. The subject combined a moralistic meaning with the depiction of a scene common to Dutch art, inspired by the everyday reality and similar to genre painting. Thus, it is the first known case in which Vermeer shows an interest in similar representations. In the painting appear, in addition to the customer and the girl, an old woman (the procuress) and a young musician, turned toward the observer: scholars have produced various elements upholding the theory that this figure can be identified as a self-portrait of Vermeer.

The artist's mother-in-law, Maria Thins, owned a painting by Dirck van Baburen, also entitled *The Procuress* (Boston, Museum of Fine Arts). In it there appear an old woman, a young woman playing music and a man holding a coin out to her. Vermeer reproduced this painting in the background of two of his paintings (*The Concert* and *A Young Woman Seated at a Virginal*), though he did not draw much inspiration from it for this 1656 composition. More significant affinities can be found with Rembrandt's work, especially in the chiaroscuro tones of the area to the left. The vivid and thickly applied colors are similar to those in *Diana and Her Companions*.

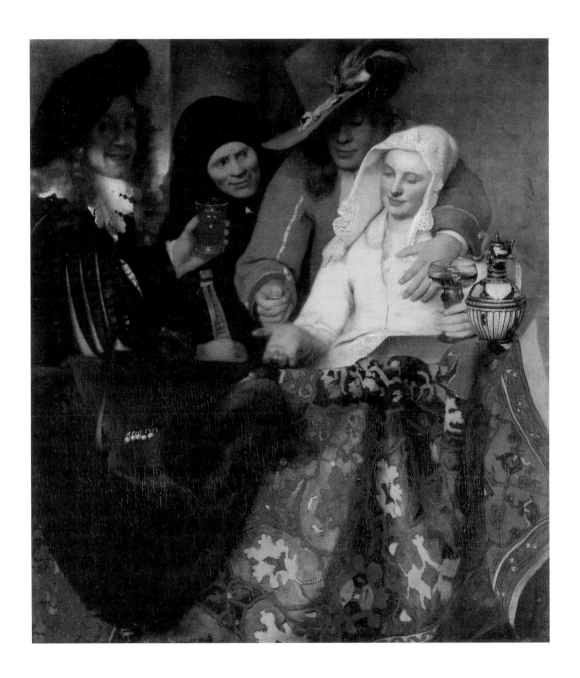

A Maid Asleep

1656–1657
Oil on canvas, 87.6 × 76.5 cm
New York, The Metropolitan
Museum of Art
Signed "I . VMeer."

Among the paintings owned by Jacob Dissius and put up for auction in 1696 was a *Drunken Servant Asleep at a Table*; the identification with this painting, donated to the Metropolitan Museum by a collector in 1913, seems almost certain.

It is not possible to define exactly the condition of the girl shown in the painting: different interpretations go along with different ideas about the meaning of the work. In effect, the girl seems to have fallen asleep because of the wine, as suggested by the jug and glass in the foreground. Thus, underlying the scene could be a moralistic appeal for temperance and moderation. The young woman's posture in fact recalls a precise image from the emblem books portraying Indolence. The bent head resting on a hand and the downcast gaze are elements traditionally used to represent Melancholy. It could be inferred that the young woman's state of mind has been caused by a disappointment in love. This second hypothesis finds confirmation in the painting shown behind the girl: it is the *Cupid* that appears more clearly in *A Young Woman Standing at a Virginal*, where an interpretation in the key of love is also proposed. X-ray analysis has shown that Vermeer had initially including the figure of a man in the back room; by eliminating him, the scene unfolds through subtle allusions, as in the later works.

In the difficult reconstruction of Vermeer's chronology, this canvas lies on a hypothetical line of development that can be traced from *The Procuress*, dated 1656, to *Woman Reading a Letter by an Open Window*. *A Maid Asleep* shares with these two works in particular the compositional device of the oriental carpet that defines the foreground. The difficult task of defining the spatial relationships is obvious in the uncertain perspective of the chair and the table, thus linking this painting to Vermeer's earlier output.

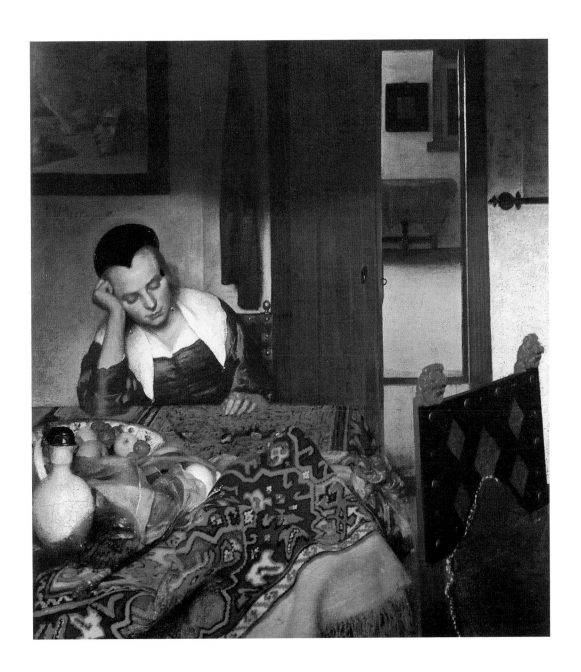

Woman Reading a Letter by an Open Window

c. 1657
Oil on canvas, 83 × 64.5 cm
Dresden, Gemäldegalerie
Alte Meister
Traces of a signature

In the eighteenth century, when this painting was added to the collections of Frederick Augustus II, elector of Saxony, it was thought to be the work of Rembrandt; later it was attributed to Govaert Flinck, his pupil, and then again to the "intimist" painter Pieter de Hooch, who lived and worked in Delft from 1654. Finally, in 1862, the painting was ascribed once and for all to Johannes Vermeer.

The scene painted is composed of just a few elements: a young lady standing by an open window reading a letter, and her absorbed expression is reflected in the glass. Around her, the space is delimited by the light-colored wall in the background that reflects the daylight pouring in from the outside, and by the objects making up the foreground. Here we see a table covered by an oriental carpet: this compositional device, enhanced by a segment of still life, also appears in *The Procuress* and *A Maid Asleep*. Vermeer has painted a greenish curtain on the right: this illusionist device appears in some works of other Dutch masters, including Rembrandt. X-ray analysis has revealed *pentimenti*, the most important one of which consists in the elimination of a painting depicting Cupid that originally dominated the background.

This painting shares its theme and its atmosphere with some works by Gerard ter Borch, with whom Vermeer was certainly in contact. Compared to his earlier output, the artist shows here a heightened sensitivity for the use of light, which was to become one of his most important stylistic traits; critics feel that study of the paintings of Carel Fabritius—who often used luminous backdrops—contributed to this development. The brushwork also shows some important innovations that foreshadowed later developments: the young woman's gown and the textiles in the foreground show highlights rendered with bright-colored *pointillés*, at times quite thickly applied. This technique, which reveals distant links with Rembrandt, led critics to talk of *ante litteram* pointillism in Vermeer.

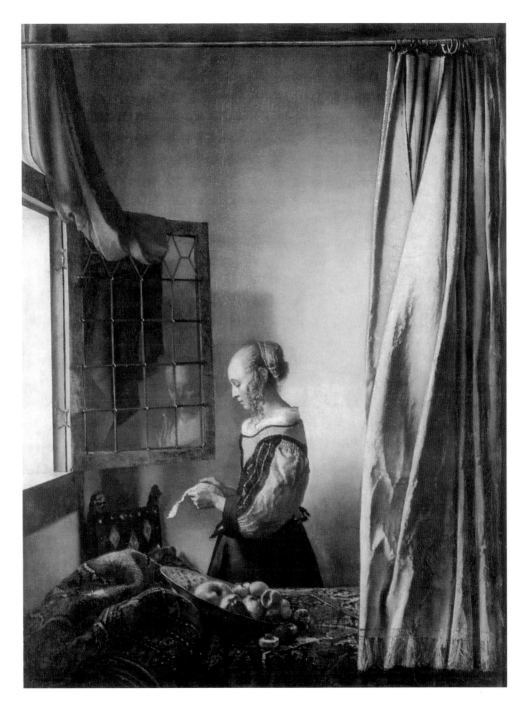

The Little Street

c. 1657
Oil on canvas, 53.5 × 43.5 cm
Amsterdam, Rijksmuseum
Signed "i VMeer"

Listed in the inventory drawn up for the auction of the Dissius collection (1696) were "A view of a house in Delft" and "A view of some houses": the titles could refer to this painting, one of Vermeer's most famous. In 1921, a private individual purchased the small canvas in order to donate it to the Amsterdam museum. The gray light of the cloudy sky dominates the scene; on the far side of the narrow, paved street for which the work is entitled, the painter framed part of a large house, the entrance to a courtyard, and the window of an adjacent building. The sense of depth is given by the succession of other buildings against the background and by the line of the gutter that starts in the foreground. In this intimate space, there are a few barely sketched out figures, intent on their chores. The painting seems to be a representation of the ideals of sobriety and industriousness that, according to the Dutch morality, should preside over the household organization. The atmosphere of hushed intimacy is, in fact, the same one that reigns in Vermeer's other paintings with interiors. It is not clear if the painter depicted a truly existing place or if it is a pastiche of real and imagined details. The tradition that would identify the main building as the painters' guild headquarters is improbable.

As in the *Woman Reading a Letter by an Open Window*, this painting recalls the work of Pieter de Hooch, in particular his so-called courtyard scenes. Along with the characteristics of the signature, this is the main factor in determining the date of the painting, which in any case is still rather controversial. Although the pointillist technique is used sparingly, concentrated in just a few points such as the plant climbing up the building exterior on the left, the artist here shows a mature perception of the light and color. Note, for example, the extraordinary virtuosity displayed in the depiction of the brick wall.

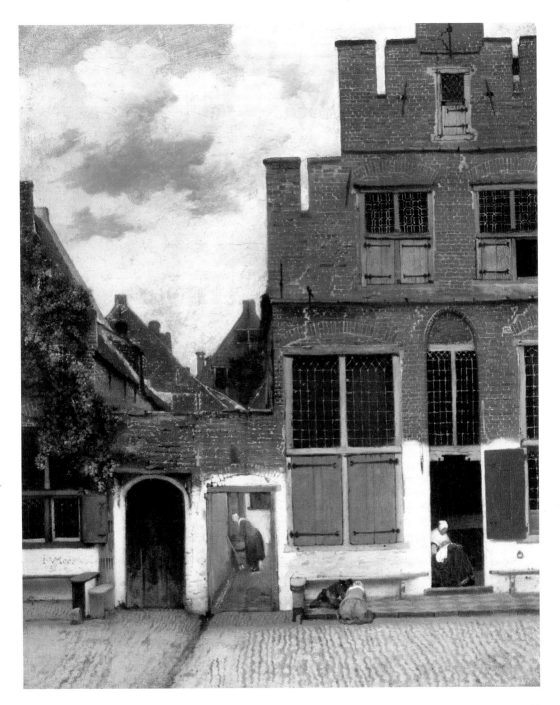

Officer and Laughing Girl

1655–1660
Oil on canvas, 50.5 × 46 cm
New York, The Frick
Collection

This painting can be recognized as one of those that went to auction in 1696, which were all probably part of Pieter van Ruijven's collection. Van Ruijven may have been Vermeer's most important patron, having bought some twenty works from the artist. It is believed that *Officer and Laughing Girl* was connected with the loan of 200 guilders made by the gentleman to the artist in 1657, maybe an advance payment for the purchase of a number of paintings done in the following years.

The scene depicted is set in a room where a soldier and a girl chat. They are seated at a table and the man is seen from the back in a rather informal stance, while the woman is portrayed with an open, laughing expression, rare in Vermeer's works. As in *Young Woman Reading a Letter*, the figures are positioned near an open window; the bright light that floods the room is reflected on the rear wall. On the surface of the table, the woman's face, and her clothing, the light becomes radiant; the motif of the grains of color that we have already seen in the Dresden Gemäldegalerie painting returns. A geographical map of Holland and Frisia dominates the room's rear wall, reproducing an etching printed by Willem Blaeu. In the foreground, the soldier has an important compositional function: the dark color further emphasizes the luminosity of the scene, while the proportions and the position of the figure heighten the sense of depth. The rendering of the space, with the obvious disproportion between the fore- and middle grounds, seems to arise from the use of an optical instrument: the effect is similar to what can be seen in a famous painting by Carel Fabritius, *View of Delft* (London, National Gallery).

Toward the middle of the 1650s, Pieter de Hooch painted various scenes with soldiers and girls; for some time this painting, too, was attributed to him, and it is hard to establish whether it was Vermeer who influenced de Hooch or the other way round. The artist painted this picture just after *Woman Reading a Letter by an Open Window*.

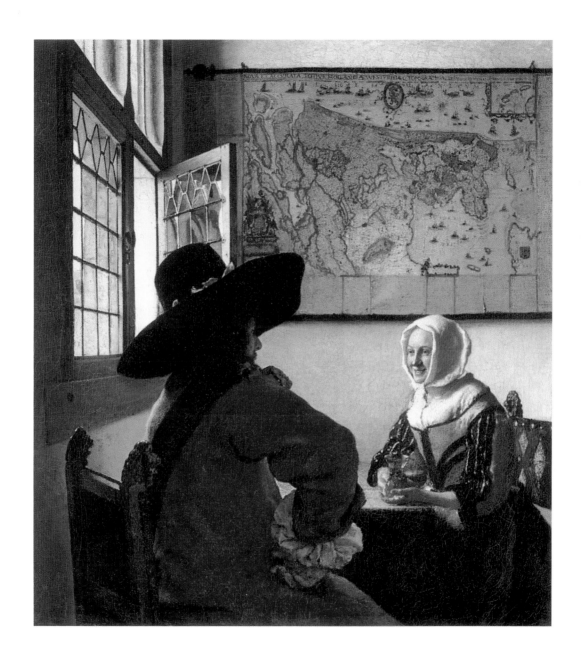

The Milkmaid

c. 1659
Oil on canvas, 45.4 × 40.6 cm
Amsterdam, Rijksmuseum

This painting reached the price of 175 guilders at the 1696 Dissius auction, second only to the *View of Delft*, assessed at 200 guilders. The later fortunes of the *The Milkmaid* as it passed through other collections, always recognized as one of Vermeer's best works, are well documented and concluded in 1908 with its purchase by the Dutch state, decided by Parliament.

In the scene depicted, the presence of decorative elements is reduced to a minimum. The attention is focused on the figure of a robust maidservant who is pouring milk into a bowl. The light passing through the window illuminates the woman, the wall behind her and the table in the foreground. On the table are arranged a few simple objects that make up an extraordinary segment of still life. The *pointillé* technique Vermeer used in some of his previous paintings can be seen here, the bright flecks on the wicker basket, the bread and the bronze pitcher, done to masterful effect. The milkmaid's bodice and apron, and the shiny bronze receptacle on the rear wall are handled the same way. This technique may have been suggested to the painter by the use of optical instruments, in which the poor focus on illuminated objects produces a similar effect. Analysis of the painting technique would indicate a date close to that of the *Officer and Laughing Girl*.

Vermeer's painting departs from the Dutch tradition of hearth scenes. The mood of the painting is established by the nature of the person portrayed, whom some have gone so far as to describe as heroic. The woman's concentration and her care in providing for the basic needs of the family illustrate the Dutch ideal of domestic virtue. This meaning is reiterated by the footwarmer on the floor and the baseboard tile with the Cupid figure, which are symbols for affection.

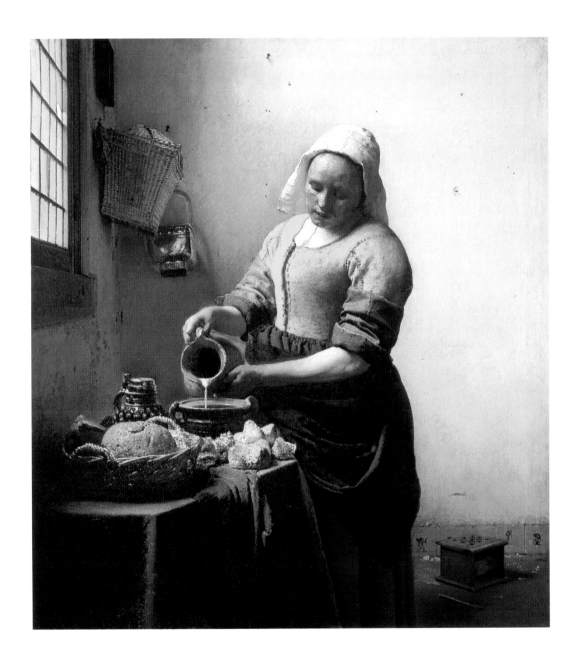

Gentleman with Girl Drinking
(The Glass of Wine)

1661–1662
Oil on canvas, 65 × 77 cm
Berlin, Staatliche Museen
Berlin, Gemäldegalerie

This picture reveals obvious thematic and formal links with *The Girl with a Glass of Wine*, which is believed to have been painted just after it. Both are akin to the genre scenes that Frans van Mieris, Jan Steen, Gerard ter Borch and Pieter de Hooch were painting in the same years, the latter artist often mentioned for his similarities with Vermeer. Compared to his works, Vermeer's paintings seem more refined, in terms of both the setting and the mood of the scene.

The canvas shows a view of an elegant room that has two windows, a table and a richly framed painting. A young woman is seated at the table, drinking wine; a white bonnet hides her face, so that her expression cannot be made out. The attitude of the man standing near her is also rather ambiguous, as he still grips the pitcher from which he has just poured the wine. The painter probably meant to depict a seduction scene, as confirmed by the theme of the wine and the presence of a musical instrument on the chair in the foreground (in the iconographic tradition, both allude to the realm of sensuality). The painting should be interpreted in a moralizing key: in the decoration of the window glass, a female figure can be seen holding out reins, an emblematic image of Temperance, and thus a call for moderation. The motif of the stained glass window can be better seen in *The Girl with a Glass of Wine*, where the amorous theme is more explicit.

This painting, which critics deem close in time to *The Milkmaid*, has very different stylistic qualities: the painting technique is more controlled and delicate, as demonstrated, for example, by the limited use of pointillism, kept to just a few segments. According to the scholars, *Gentleman with Girl Drinking* inaugurates a series of paintings in which Vermeer gradually abandoned the free application of paint in favor of finer brushwork, more suited to the portrayal of elegant scenes.

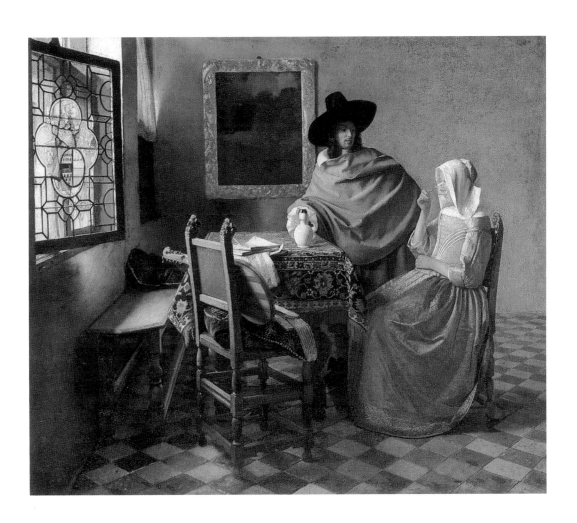

The Girl with a Glass of Wine

c. 1659
Oil on canvas, 77.5 × 66.7 cm
Brunswick, Herzog Anton
Ulrich-Museum
Signed "IVMeer"

This may have been the Merry company in a room painting sold at the Dissius auction of 1696 for 73 guilders; in 1710 it was described in similar terms in the collection of Duke Anton Ulrich, where it has remained.

In a room quite similar to that of *Gentleman with Girl Drinking*, three figures are portrayed. In the foreground, an elegantly dressed girl is sitting on a chair while a courtier encourages her to drink from the glass of wine that she holds in her right hand. The man looks at her engagingly, but she turns her gaze to the observer, with a strange smile that has been variously interpreted: it could be the sign of a slight inebriation, or an expression of pleasure at the gentleman's attentions. The state of the man in the background is not clear either. Perhaps he has fallen asleep as a result of the wine, or perhaps his melancholy attitude betrays disappointment at the girl's lack of interest. As in the painting just before this one, a call for morality and restraint is implied. The austere portrait in the background seems to be alluding to this, as does, in particular, the stained glass window. In fact, in the window decoration, there is a medallion with a female figure, interpreted as an allegory of Temperance and present in both paintings. The innermost tondo instead displays a coatofarms: it is the crest of a woman who had lived in Delft years earlier, Janetge Vogel. It is not possible to imagine that she was a patron of the painter's, and we must simply think that he reproduced a window he saw on some occasion.

The compositional scheme recalls precisely that of *Woman Drinking with Two Soldiers* by de Hooch (1658, Paris, Musée du Louvre); the style continues the refined direction first taken in *Gentleman with Girl Drinking*.

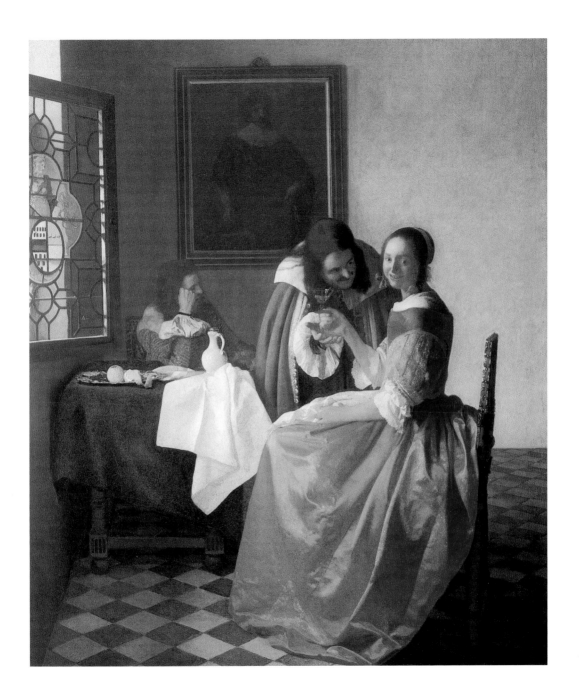

Girl Interrupted at Her Music

c. 1660
Oil on canvas, 39.3 × 44.4 cm
New York, The Frick
Collection

This painting appeared for the first time in 1810 at an auction held in Amsterdam, and is in a very poor state of conservation, to the point where it is difficult for critics to formulate knowledgeable evaluations. In any case, the similarities with *Gentleman with Girl Drinking* and *The Girl with a Glass of Wine* are apparent, and in some ways this painting seems to be a synthesis of the two.

The scene, which has been given various conventional titles, is set in a room that is rather like that of the other two paintings; the window, the table and the chairs, the painting on the rear wall are all repeated. In the foreground, a seated young lady holds a musical score in her hands, while a gentleman leans tenderly toward her. The allusion to the theme of love can be sensed here, too, though it is carried out on a different plane: all trivial elements are eliminated, lending the scene much more lyrical accents. There is nothing ambiguous about the gestures of the protagonists, and the subject of the painting in the background, a cupid with a playing card, recalls the motto, "Perfect love is for but one lover." The girl's gaze, out of the picture toward the observer, seems to confirm the seriousness of the message; the same painting will be used again in *A Young Woman Standing at a Virginal*, where the central figure also gazes out toward the viewer. There is a spurious element in the composition: the birdcage hanging on the side wall was added by another artist at a later date, when a violin and bow were also painted, later removed by restorers.

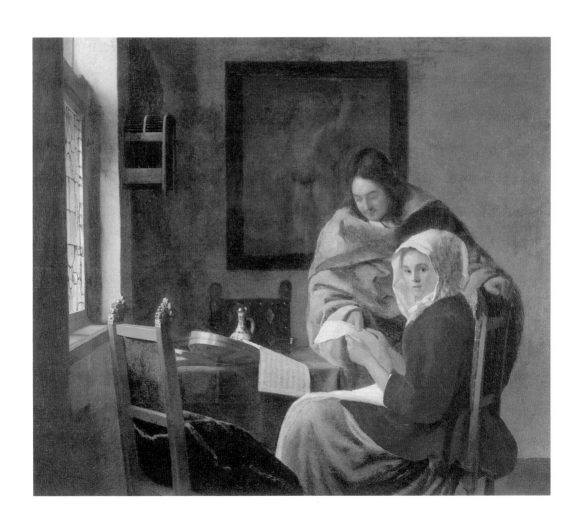

View of Delft

c. 1660
Oil on canvas, 96.5 × 117.5 cm
The Hague, Koninklijk
Kabinet van Schilderijen,
Mauritshuis
Signed "IVM"

"The city of Delft in perspective, seen from the south" was included in the 1696 Dissius auction and sold for 200 guilders, fetching the highest price. In 1822, at a sale held in Amsterdam, William I purchased the painting for the royal picture gallery, despite the indifference of the museum director of the time.

In the painting, which is larger than Vermeer's other mature works, there is a view of the city from the port area; the city walls, the Schiedam gate with the clock, the Rotterdam gate with the twin towers, and at the center, the Nieuwe Kerk belltower can all be recognized. The uniqueness of this painting does not, however, lie in its subject. In seventeenth-century Dutch art, city views were not uncommon, and often they were shown in the margins of large topographical maps, as illustrated, among others, on the rear wall of one of Vermeer's paintings. Rather, the technical and expressive qualities are what make this view extraordinary: critics have pointed out how the artist reprocessed the real details, simplifying them and redistributing the volumes of the buildings, though they are still recognizable. In this way he achieved a sort of horizontal frieze, spread out in contrast with the vastness of the cloudy sky. The stylization is even more apparent in the experimentation with chiaroscuro effects, heightened by the reflections on the water. The light is modulated into many hues, and the shadows of the foreground contrast with the illuminated roofs in the background. Variations in the brushstroke render the diverse materials (tiles, stone, sand) as the light strikes them.

The possibility that the artist was inspired to paint an image of the city as he saw it in a *camera obscura* is secondary with respect to the atmosphere of the scene, which, like *The Little Street*, conveys a sense of serene activity. Critics see in this work the start of the artist's stylistic maturity, represented by the output of the early 1660s.

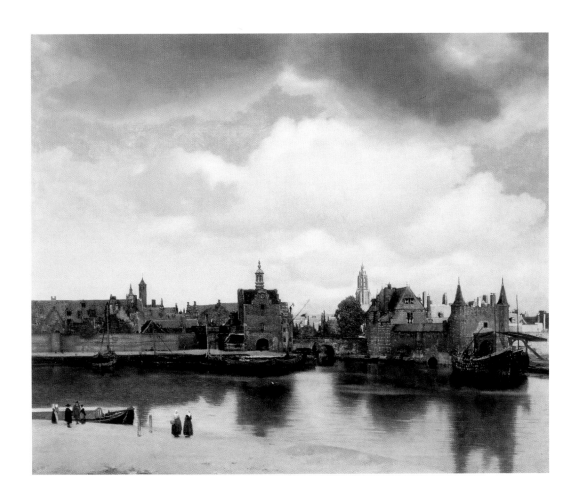

Gentleman and Lady
at the Virginal
(The Music Lesson)

c. 1662
Oil on canvas, 74 × 64.5 cm
London, Buckingham Palace,
Royal Collections
Signed "IVMeer"

The history of this picture is rather interesting. It was mentioned in the Dissius collection inventory, and in 1718, the Italian painter Gianantonio Pellegrini, who was in Holland at the time, purchased it. The next owner, the English consul at Venice Joseph Smith, gave it to George III in 1762, in exchange for a canvas by Frans van Mieris.

The painting shows a room drenched in sunlight; against the backdrop is a woman seen from the back playing the virginal, while the gentleman next to her listens attentively. The woman's face is reflected in a mirror, which also reflects the leg of the easel used by the painter. Presumably, in this way Vermeer sought to call attention to his own role as creator. The scene is the fruit of his invention and he is in control of it. Indeed, it has been pointed out that this painting is orchestrated according to very strict geometric laws, so that bold associations may be drawn between the composition and musical forms.

Through a dense play of references, Vermeer illustrates the comparison between music and love. Both are based on the principle of harmony and offer consolation and comfort. Painted on the virginal, in fact, is the Latin motto "Music: companion of joy and balm for sorrow." The inclusion of a viola suggests that this instrument will echo the sound of the virginal, in the same way as the feelings of two persons who love one another. In effect, the gentleman's stance seems dictated by such a harmony.

Though the subjects are completely different, this painting is very close to the style of the *View of Delft*: the rigorous control of the composition and even the ability to render with the brushstrokes the varied textures of the materials. In this respect, note the freedom of the brushstrokes applying liquid color that Vermeer used to render the marble veins of the flooring.

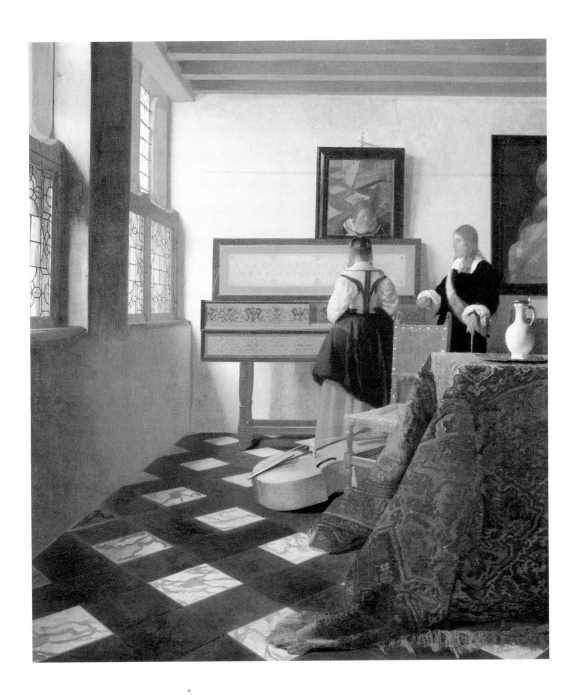

Woman in Blue Reading a Letter

c. 1663
Oil on canvas, 46.6 × 39.1 cm
Amsterdam, Rijksmuseum

This painting has always been greatly admired. In 1839, an English dealer sold it to the banker Andriaan van der Hoop, the owner of a wonderful collection. In 1885, his 225 paintings, among which was Rembrandt's _Jewish Bride_, were donated to the city of Amsterdam. _Woman in Blue Reading a Letter_ was Vermeer's first work to enter the Rijksmuseum collections.

The artist returns here to a theme he took up in a painting in his early period. Before a window, the luminous presence of which can only be sensed, a woman is intently reading a letter. The arrival of the post has perhaps interrupted her in her everyday activities, making her abandon on the table the pearl necklace she was about to put on. Other Dutch artists have also approached the theme of the letter in their works, emphasizing its sentimental connotation. This is not the case with Vermeer, who gives no clues about the woman's state of mind. It has been suggested that she is with child (as implied by the matronly shape of the attire), and that the empty chair and the geographical map on the rear wall of the room allude to the distance of a loved one.

The artist used all the expressive devices at his disposal to imbue the scene with a mood of calm stasis. He studied and corrected the placement and the proportions of the objects, simplifying the composition and constructing it with mathematical rigor. The woman is enclosed within a particular space, dominated by her statuary figure. The simple chromatic harmonies, based on shades of pale blue, yellow and ochre, heighten the peaceful atmosphere of the painting. The bluish nuances of the shadows on the wall create a pale and delicate light, attuned to the thoughtful attitude of the protagonist. This extraordinary stylistic balance and the ability to calibrate all the pictorial devices in service of the emotional content of the scene are typical of the works of the early 1660s.

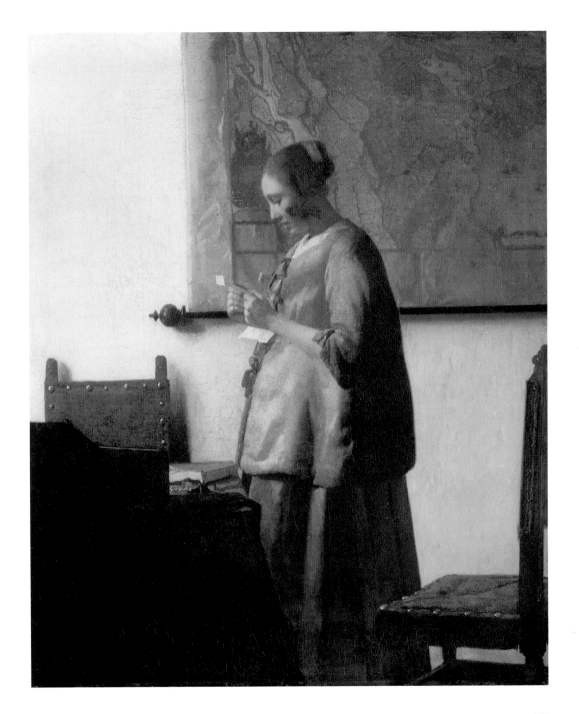

Woman Holding a Balance
(The Weighing of the Pearls)

c. 1664
Oil on canvas, 42.5 × 38 cm
Washington, D.C., National
Gallery of Art

The history of this painting is well documented, starting with the 1696 Dissius auction: the same collector who was the highest bidder for *The Milkmaid* purchased it. Afterward, it passed through a number of collections before coming to rest in the United States in 1911. The last owner donated it to Washington D.C.'s National Gallery.

In the painting, Vermeer shows a woman holding a scale in equilibrium; on the table before her sit jewelry cases and necklaces. The diffuse light that filters through an orange curtain lights the scene; the rear wall is dominated by a painting of *The Last Judgment*. This last feature, along with the presence of the jewels and the scale, has given rise to a number of allegorical interpretations. It has been suggested that the woman is a personification of *Vanitas*, that is, of the transience of earthly things. Attachment to material things is contrary to religious principles, evoked by the presence of the *Judgment*. In contrast, it has also be said that woman could be a positive figure, comparable, even, to the Madonna, who intercedes in the Universal Judgment: the pearls could allude to her purity and the expectant state that characterizes her as the Savior's mother. A new interpretation has been formulated following X-ray analysis revealing that the scale pans do not contain pearls, but are empty. This has suggested that the scene represents a call for temperance: the woman weighs her own actions with the same severity with which Christ judges individuals. The mirror before her is an invitation to self-awareness. It has been pointed out that such an interpretation shows precise references to Saint Ignatius of Loyola's *Spiritual Exercises*.

Pieter de Hooch also painted this subject: it seems to be an established fact that his picture served as inspiration to Vermeer, who modified its mood and import.

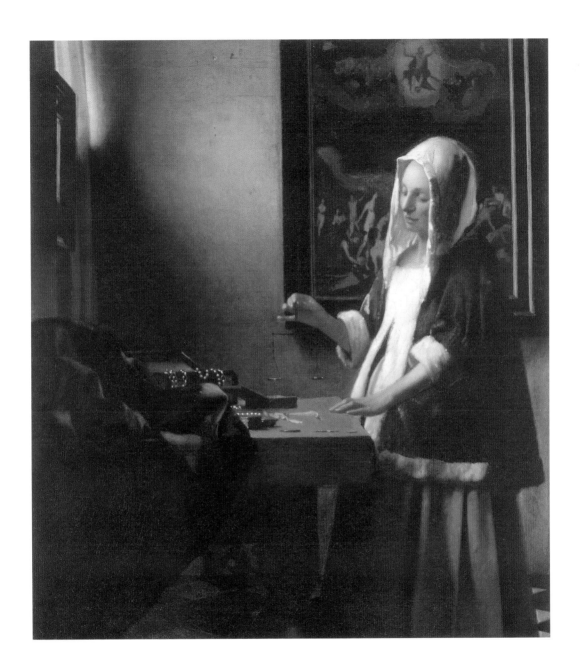

Woman with a Lute

early 1660s
Oil on canvas, 51.4 × 45.7 cm
New York, The Metropolitan
Museum of Art
Signed "Meer" (signature
damaged)

Like *Girl Interrupted at Her Music*, this painting is in a poor state of conservation. Extensive abrasion of the painted surface and the consequent loss of chromatic and chiaroscuro effects make Vermeer's pictorial technique all but unrecognizable here, and as a result, there is also a certain difficulty in dating it. However, in other respects, *Woman with a Lute* displays all the characteristic features of Vermeer's works of early maturity.

The scene is set in the corner of a room illuminated from the left. A young woman playing the lute sits behind a table, wearing the same jacket shown in *Woman with a Pearl Necklace* and other works of these years. The young woman is captured in a moment of attention, as if she were trying a note on the instrument. A large geographical map of Europe, recognized as the one published by Hondius in 1613, hangs on the rear wall. The spatial depth is not suggested by the usual perspective means, but simply by the juxtaposition of near and far objects. As in other works, this could suggest, therefore, the use of an optical instrument. It would also explain the conspicuous disproportion of the chair and the drapery in the foreground. This feature could recommend moving the dating up to the period of the *Officer and Laughing Girl*, but in the critics' assessment, the main factor is apparently the consonance between the mood of this painting and that, for example, of *Woman with a Pearl Necklace*.

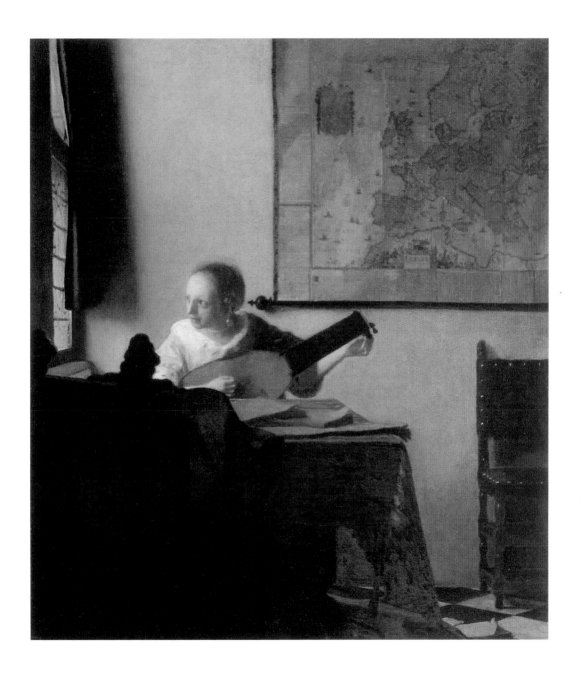

Woman with a Pearl Necklace

c. 1664
Oil on canvas, 51.2 × 45.1 cm
Berlin, Staatliche Museen
Berlin, Gemäldegalerie
Signed "IVMeer"

W*oman with a Pearl Necklace* was one of the twenty-one paintings documented as part of Jacob Dissius's collection; it later passed into the hands, among others, of Thoré-Bürger, one of the first scholars to study Vermeer. In 1874, it was purchased for the Royal Museum of Berlin.

The scene has as its protagonist a young woman before a mirror wearing a pearl necklace. She wears a yellow satin jacket edged in ermine, and her hair is decorated with a red ribbon. On the table before her rest a powder puff and a basin; the scene, like all those painted in the same period, takes place in the corner of a room illuminated by a window. As in the previous *Woman Holding a Balance*, critics do not agree in their interpretation of the meaning of the scene. In effect, the theme of the "vanity of the vanities," traditionally associated with this type of image, seems to be in strong contrast with the mood of this painting. In a painting by Frans van Mieris (Berlin, Staatliche Museen), which may have served as a model for this one, the woman is sensual and seductive, while here she is demure and absorbed. Thus, it is possible that through a series of metaphorical associations, the woman personifies such positive values and purity and truth. Reference to the symbolism of emblems would justify an interpretation of the mirror as a truthful reflection of reality. X-ray analyses carried out on the painting have not helped to solve the ambiguity; the painter had initially included in the composition a geographical map and a lute, allusions to worldly life and sensual love. It is impossible to determine whether their elimination corresponded to an iconographic problem, or, instead, a compositional one.

From a stylistic point of view, this painting shows the same constructions as *Woman Holding a Balance*, though translated into a brighter and more intense chromatic range.

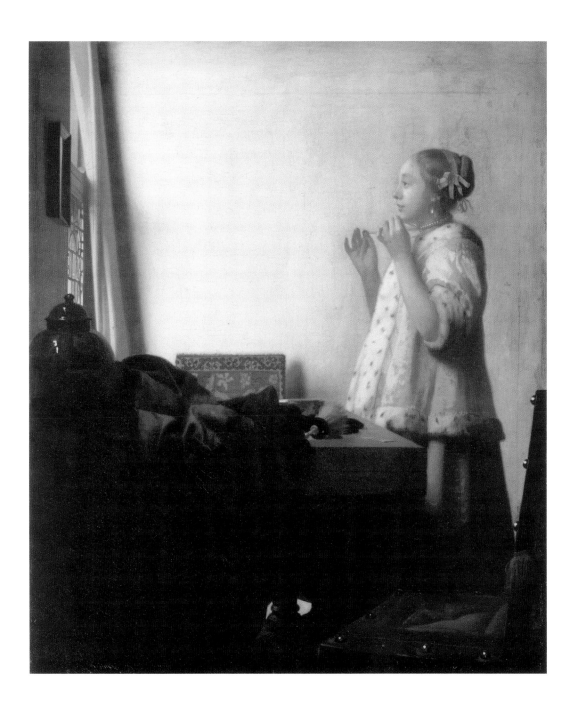

Young Woman with a Water Pitcher

early 1660s
Oil on canvas, 51.4 × 45.7 cm
New York, The Metropolitan
Museum of Art

The group of paintings from the mid-1660s, with single female figures alone in scenes of absolute compositional rigor, concludes with *Young Woman with a Water Pitcher*, which for a time was attributed to Gabriel Metsu. After passing through various collections, in 1888, the last owner donated it to the Metropolitan Museum.

The scene is constructed in the usual way: the light comes from the left and illuminates a corner of a room. Here, there is a modestly dressed woman who holds a pitcher in one hand and rests the other on the open window. The thoughtful attitude is emphasized by the downcast eyes, which seem to be directed to the exterior. No precise action is depicted in the painting: the pitcher, the basin and the woman's bonnet and mantle all seem to allude to the moment of her *toilette*, but there are no elements to confirm it. In the tradition of emblems, the theme of bathing is associated with the idea of purity and innocence, and there is no reason to believe that Vermeer did not want to express this theme.

A nineteenth-century observer noted about this work that "the way of depicting the effect of the light through the pale bluish glass of a window" seems to be the main purpose of many of Vermeer's paintings. In effect, as already seen in *Woman in Blue Reading a Letter*, the light is treated with great sensitivity. Note, for example, the violet shades of the reflection on the wall and in the delicate half-tones of the woman's face. The edge of the dress is shaded with delicate brushstrokes, to soften the reflected light on the curve of the fabric. It can also be seen with the naked eye how the artist initially intended to show a chair on the left; by eliminating it, the light directly reaches the figure, which is practically isolated in an immobile space.

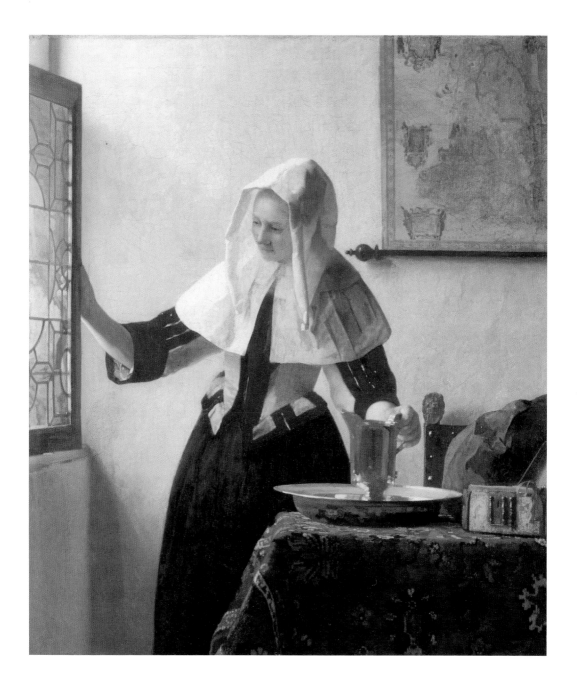

A Lady Writing

c. 1665
Oil on canvas, 45 × 39.9 cm
Washington, D.C.,
National Gallery of Art
Signed "IVMeer"

A *Lady Writing* can be recognized among the paintings sold at the auction of 1696, so presumably it belonged to the collection of Pieter van Ruijven along with another twenty-one paintings by Vermeer, including *Woman with a Pearl Necklace*, which is quite similar to this one.

The scene takes place in penumbra: at the center of the canvas the figure of a young woman stands out. She is seated at a table and gazes toward the observer. She holds a goose feather in her hand, which still rests on the letter paper. She seems to have interrupted her writing for a minute, which suggests that Vermeer wished to show her reaction to the entrance of a second person, who remains hidden. Nothing in her expression, however, confirms this hypothesis. It does not seem possible to discover in the scene even hidden symbolic meanings. Although the theme of the letter has often been used in Dutch painting to refer to love, here other apparent indications in this respect are lacking. In the painting shown on the rear wall, a still life with musical instruments has been made out, another possible reference to the erotic sphere. Presumably, this picture is, instead, a portrait, which would explain the young lady's gaze and her placement in the foreground. The hypothesis that the woman portrayed is the painter's wife is interesting, but without foundation. The inventory of the family's assets attests that the yellow satin jacket belonged to Vermeer's wife, but it is worn by other models in some paintings.

The scene, like *Woman in Blue Reading a Letter*, painted just prior to it, is constructed through deliberate proportional relationships that involve all the elements of the composition. The figure stands out among a fabric of horizontal and vertical lines that confer on the painting the characteristic mood of quiet solemnity.

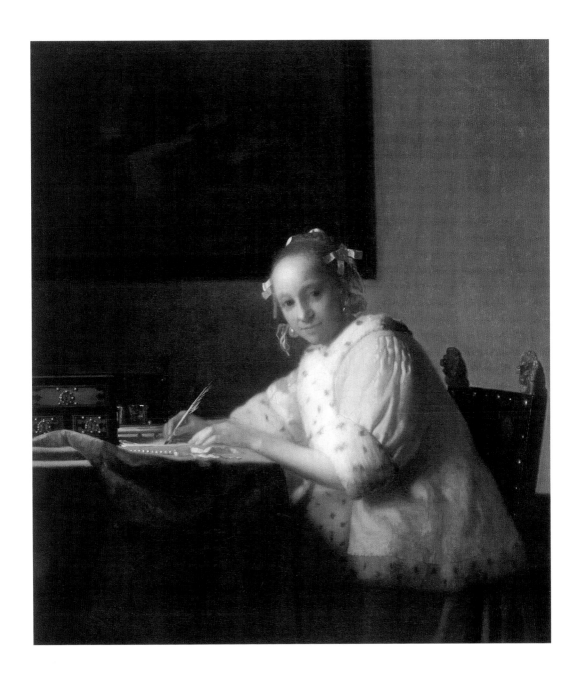

Girl with a Pearl Earring

c. 1665

Oil on canvas, 44.5 × 39 cm
The Hague, Koninklijk
Kabinet van Schilderijen,
Mauritshuis
Signed "IVMeer"

From the documents, Vermeer seems to have painted more than one *tronie*; this was a rather widespread genre that is a sort of blend between a portrait in costume and painting history. In these paintings, the artists portrayed models dressed in exotic or antique costumes, using them to depict historical and biblical figures. *Girl with a Pearl Earring* falls under this category, a delightful painting that some have called "the Dutch Mona Lisa." However, it is not possible to recognize it among those generically mentioned by the sources: two "*tronien* painted in the Turkish style" listed in the inventory of the Vermeer family's assets drawn up in 1676, and three put up for sale at the 1696 Dissius auction. The first sure information dates from 1881, when a sharp-eyed collector picked it up for a trivial sum, and then bequeathed it to the Mauritshuis in 1902.

Vermeer painted a girl in three-quarter view, with her lips slightly parted and a liquid gaze; the pose and the expression convey a sense of extraordinary immediacy. The model wears a yellow garment and a pale blue turban from which hangs down a yellow scarf; she wears a teardrop pearl earring with an opalescent shine. Vermeer may have wished to depict a muse or a sibyl, but no iconographic attribute helps to identify the figure.

The painting is rather damaged, and there is an obvious *craquelure*; however, the soft shading of the face and the skillful use of transparent varnish in the blue areas of the headdress can still be appreciated. The neutral, dark background appears here for the first time in Vermeer's painting, and invites comparisons with the *tronien* of Michael Sweerts, active in Amsterdam from 1660–1661.

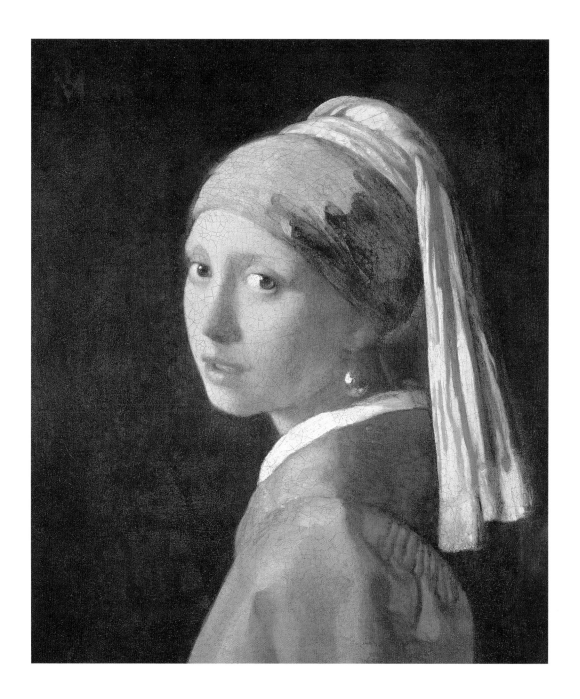

The Concert

c. 1665
Oil on canvas, 72.5 × 64.7 cm
Boston, Isabella Stewart
Gardner Museum

This painting, which among others belonged to the scholar Thoré-Bürger, shows clear similarities with *The Music Lesson*; Vermeer's painting technique and the seeming naturalness of the scene, however, suggest a date later than the period of the single figures of 1663–1665.

The setting is like that of the previous musical painting: the figures are arranged in a room with a black-and-white checked floor, furnished with a table carelessly covered with a woolen carpet. The musical instrument, a harpsichord, stands against the rear wall; in the foreground there are sheets of music, a stringed instrument, and a viola abandoned on the floor near the table. The figures are deployed against the rear wall: a woman, seated, plays the harpsichord; a man seen from the back accompanies her and a second young lady standing to the right sings and keeps time. Two paintings are hung on the rear wall: one shows a wooded landscape which seems to have been painted in a contrasted and dramatic mood, while the other can be recognized as Dirck van Baburen's *Procuress*. This work, which also appears in the *A Young Woman Seated at the Virginal*, was part of Vermeer's collection and is among those listed in the inventory of the family's assets drawn up after the painter's death.

The similarity to *The Music Lesson* and the presence of the "painting within a painting" motif suggests a symbolic value for the scene. The traditional association between music and sensual love seems to find confirmation in the painting to the right; but the behavior between the figures suggests no bond of this sort. To the contrary, the tacit harmony that joins them evokes the spiritual significance already presumed for *The Music Lesson*; the paintings in the background would thus be shown for the purpose of contrast.

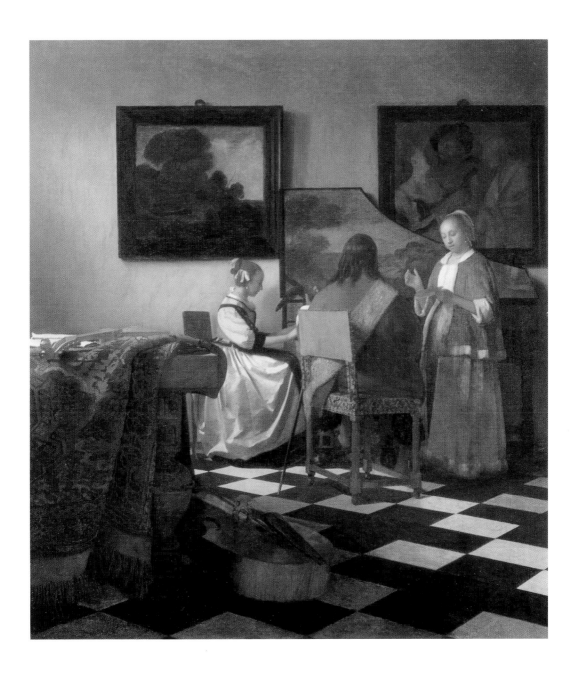

Girl with the Red Hat

c. 1665
Oil on panel, 23.2 × 18.1 cm
Washington, D.C.,
National Gallery of Art
Signed "IVM"

The fact that the first time we hear about his painting dates to a Paris auction of 1822 seems to confirm doubts about its authenticity that were advanced by scholars on the strength of considerations of a formal order. *Girl with the Red Hat* does, however, have roots in the genre of orientalizing heads (*tronien*), mentioned in two different documents with reference to Vermeer's output.

In the painting, there is a girl turned in three-quarters view toward the observer. The curious, red-feathered hat adorning her suggests an interest in exotic attire, which it shares with *Girl with a Pearl Earring*. The model's expression here, too, recalls this painting, though the setting is quite different. Behind the girl there is a brocaded fabric, while the back of a chair, across which the girl rests her arm, dominates the foreground. Oddly, the lions' heads that decorate the finials of the chair are turned toward the exterior. Other things, however, have contributed to the hypothesis that this work is a fake: the painted support is a panel rather than Vermeer's customary canvas, and the brushwork, extremely free, is like none other in the ascertained works. This panel may document further experimentation with some of the optical principles tested elsewhere: there is a tendency to leave the image in the foreground slightly out of focus and to blur the outlines of the figures and the objects to emphasize the light striking them. Also, the device of coloring the highlights, as can be seen in the reddish tones that the hat projects onto the girl's face, is typical of the artist. Finally, analysis of the painting technique has shown the use of procedures quite similar to those used in *Woman Holding a Balance*, which is close in date to this work. X-ray analysis has revealed the presence on the panel of a prior painting, in the style of Rembrandt. This fact has been the subject of different evaluations.

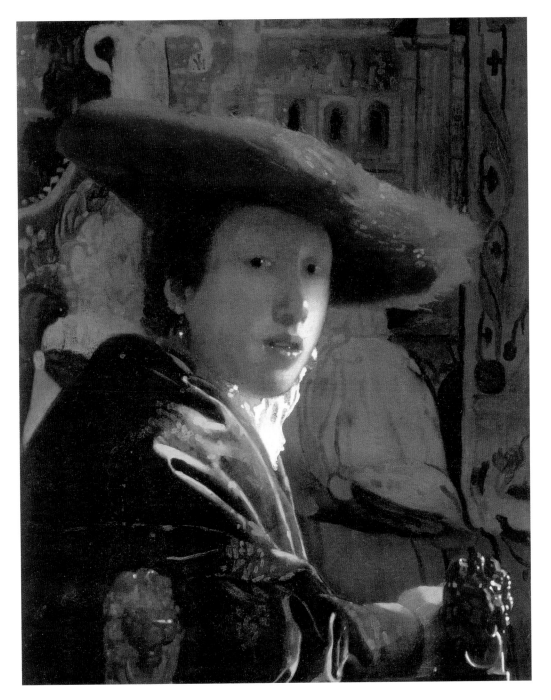

Girl with a Flute

1665–1670
Oil on panel, 20 × 17.8 cm
Washington, D.C., National
Gallery of Art

Like *Girl with the Red Hat*, which almost seems its pendant, this painting is much debated. Information about its passage through various collections does not date any earlier than the nineteenth century, and a reference to the *tronien* listed in Vermeer's collection and that of Dissius can be associated with it only hypothetically.

The gaze of the young woman shown in this painting, the presence of an exotic headdress, the tapestry in the background and the lion's head finials of the chair all clearly recall *Girl with the Red Hat*. In both cases, the artist used a wooden support that he painted with such freedom of brushstrokes as to suggest a nineteenth-century forgery. However, it has already been demonstrated how this style could be considered an extreme evolution of some tendencies inherent in Vermeer's art. In *Girl with a Flute*, though, the technique is so unrefined that it is difficult to attribute it to the artist's hand. There is significant uncertainty about its dating, which critics place between 1665 and 1670.

Analyses carried out on the painting with the help of technical means have provided interesting clues: the wood of the panel is old, and some of the pigments used were those that Vermeer preferred. Significant changes after the first drafting phase have been detected. In the layer of paint relative to this rough version, there is evidence of scraping, which might be explained in one case by conjecturing that a long time passed between the first layer of paint and the one successive to it. Thus, Vermeer may have left the work unfinished at his death, and another artist could have finished it later. In particular, the name of the painter Jan Coelenbier has been suggested; he was the one who bought in 1675 the entire lot of paintings owned by the artist's widow, including, as a matter of fact, two *tronien*.

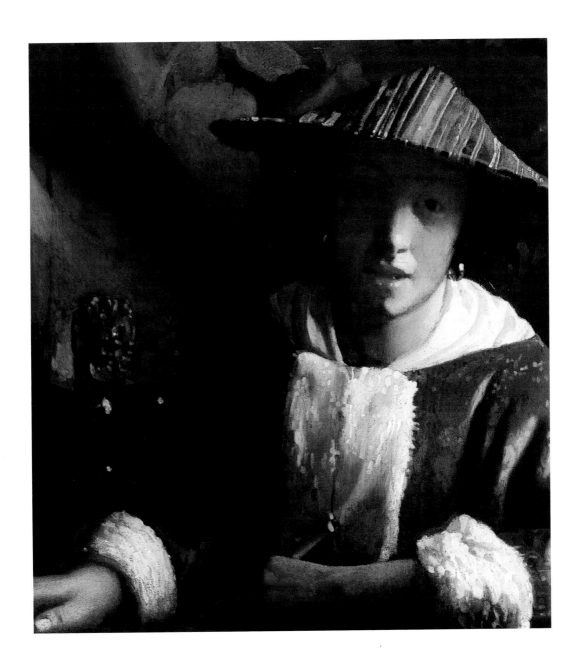

Study of a Young Woman
(Girl with Veil)

1665–1667
Oil on canvas, 44.5 × 40 cm
New York, The Metropolitan
Museum of Art
Signed "IVMeer"

It is not possible to establish sure links between this work and those presented at the 1696 auction. As with the other paintings of heads, its ascription to the Dissius collection may only be proposed hypothetically. The first sure information about this picture must be sought in a later period, and is related to the nineteenth-century collections.

The painting has many formal similarities with *Girl with a Pearl Earring*: a young model with a covered head turns her gaze toward the viewer, and her luminous figure stands out against a dark, undefined background. Both girls wear pearl earrings, and their attire is described with simple lines of blues and yellows, in a range of shades. Compared to the girl with the turban, the one shown in this picture is described more realistically: her features are not pure and idealized, but, rather, markedly individual. The sweet gaze and the facial lineaments (wide-set eyes, thin lips, wide forehead) recall the physiognomy of the *Lady Writing*: thus, Vermeer presumably portrayed a person close to him in the two canvases, perhaps his wife or daughter.

Since the handling of the face through subtle shifts in tone is like that of *Young Woman with a Water Pitcher*, this canvas can be dated just after 1665; a form of abstraction typical of the later works would suggest this.

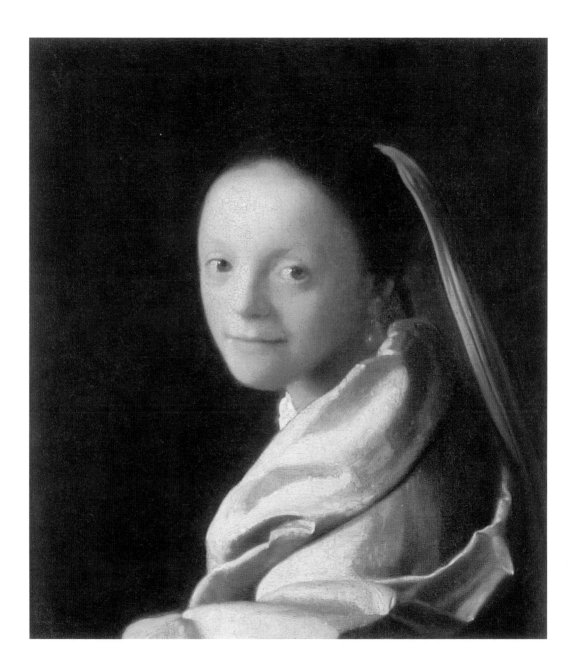

The Art of Painting

c. 1666
Oil on canvas, 120 × 100 cm
Vienna, Kunsthistorisches
Museum
Signed "I Ver. Meer"

It appears that on February 24, 1676, Vermeer's widow, Catharina Bolnes, transferred to her mother the ownership of a painting entitled *The Art of Painting*, against loans never paid back; it seems that the woman was trying to save the painting from imminent sale at the auction of all her goods, consequent to her declaration of bankruptcy. The following year Maria Thins notified that, despite the transfer, the official receiver had included the painting in the notice of auction. The outcome of the episode is not known, nor can a sure connection be established between *The Art of Painting* and the Portrait of Vermeer in a Room with Various Accessories that turned up at the 1696 Dissius auction.

The picture can certainly not be interpreted as a self-portrait, since the painter is shown from the back. It does, however, fall under a precise iconographical category in which artists portrayed themselves in their studios, in the act of painting. In Vermeer's work, the painter is seated before the easel and is beginning to sketch out the image of a model on the canvas: the woman stands before him, against the rear wall of the room. She is wearing a pale blue mantle and holds a few attributes that identify her as an allegorical figure: a crown of laurel, a trumpet and a book. Critics have seen her variously as a representation of Fame or of Clio, the muse of history. Apparently, the painting has a symbolic value, relative to the role of art and the figure of the painter. In this respect, critics have put forth conflicting interpretations, often involving the geographical map shown against the rear wall; whatever its meaning, this painting is an extraordinary study of lighting effects.

The presence of the tapestry, hung like a stage curtain in the foreground, equates the picture to the output of the late-1660s: the interpretation in a decorative key of the composition and of the single elements also brings to mind the style of these works.

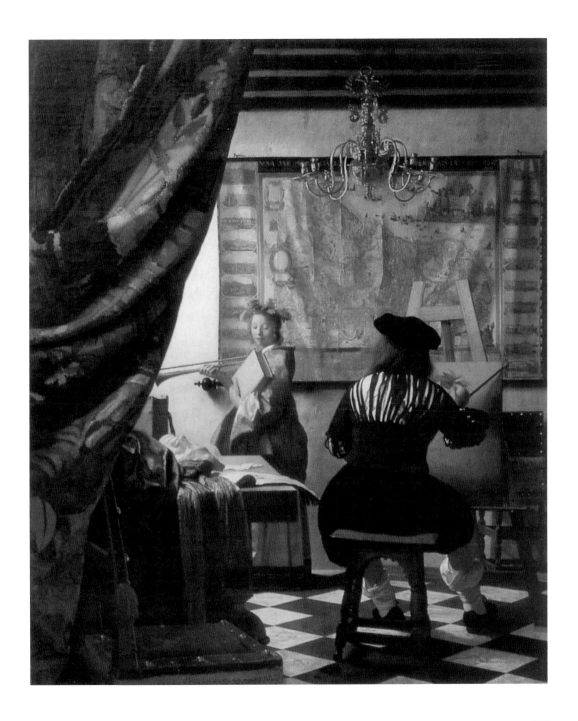

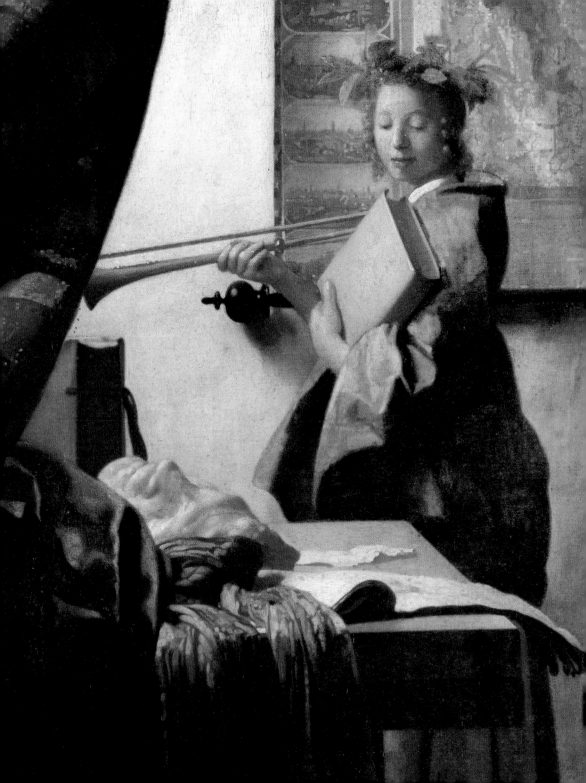

Mistress and Maid
(Maidservant Holding a Letter out to Her Mistress)

1665–1670

Oil on canvas, 90.2 × 78.7 cm
New York, The Frick
Collection

The picture described in the Dissius inventory as "A young lady to whom a maidservant holds out a letter" could be this one, or the later one (Amsterdam, Rijksmuseum) illustrating the same subject. This confusion also complicated the reconstruction of the nineteenth-century passages through collections, though it has now been cleared up.

In the painting, Vermeer portrays a young maidservant taking a letter to her mistress. The mistress, who clearly had been writing, lays her pen down on the table and reacts in surprise. The attitude of the maidservant, who is leaning forward and seems to be speaking, and the gesture of the lady, who brings her hand to her face, imbue the scene with a dramatic quality that until now has not appeared in Vermeer's work. Vermeer took on the theme of the letter three times in the course of his mature output. Clearly, in these cases, the introduction of the maid requires an interpretation in a narrative key of the theme, which had always taken place before in terms of quiet reflection.

The artist sets the scene against a dark, uniform backdrop. This device, never before experimented with a composition in a domestic setting, is taken from the two paintings with girls' heads, where it was likewise used to highlight the figures. The cold light illuminating the face of the lady is close to that of the *Study of a Young Woman*, datable to circa 1666. Note the strong chiaroscuro effects on the sleeve of the yellow satin jacket, so different from the delicate halftones of the slightly earlier *Lady Writing*: on the other hand, the effect is quite similar to that seen in *The Geographer*, datable to about 1668, where the figure also has the same dynamic posture.

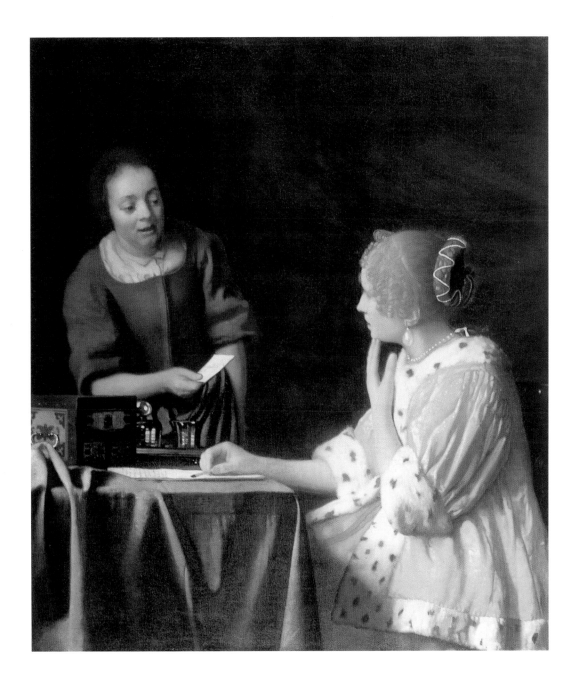

The Astronomer

1668
Oil on canvas, 50 × 45 cm
Paris, Musée du Louvre
Signed and dated
"IVMeer M DCLXVIII"

The first information we have about this picture dates from the eighteenth century. Until the close of the century, the painting circulated on the art market together with what in any case must be its pendent, *The Geographer*. Both pictures have male protagonists, a unique circumstance in Vermeer's work: they are two scientists shown accurately among the instruments of their activity. These characteristics, unusual for a painter who liked to portray female figures busy in simple, everyday activities, suggest a client specifically interested in these themes. They are probably two portraits of the same person, whose identity must be sought among the Dutch intellectuals of the time. The hypothesis that the patron (or the person portrayed) is the scientist Antony van Leeuwenhoek, for whom scholars have long sought links of friendship with the painter, is tempting, but not supported by reliable documents.

The scene is constructed according to the typical models for portraits of intellectuals. The astronomer is shown in his studio; around him are displayed the tools he uses: books, a graph, an astrolabe and a compass. He sits at a table, upon which rests a globe of the heavens that reproduces with extraordinary fidelity the one designed by Jodocus Hondius in 1600. In the scene, the protagonist is getting up from his chair and turning this globe, as if to check or seek some information. This immediate and natural gesture confers on the work the same narrative quality as *Mistress and Maid*. Any symbolic content suggested by the critics becomes clearer when analyzed in the light of its relationship to *The Geographer*.

Apart from *The Procuress* of 1656, this is the only dated painting in Vermeer's ascertained output, although the authenticity of the inscription that appears on the wardrobe has been cast in doubt. *The Astronomer*, in any case, remains a fundamental reference point for reconstructing the artist's stylistic evolution.

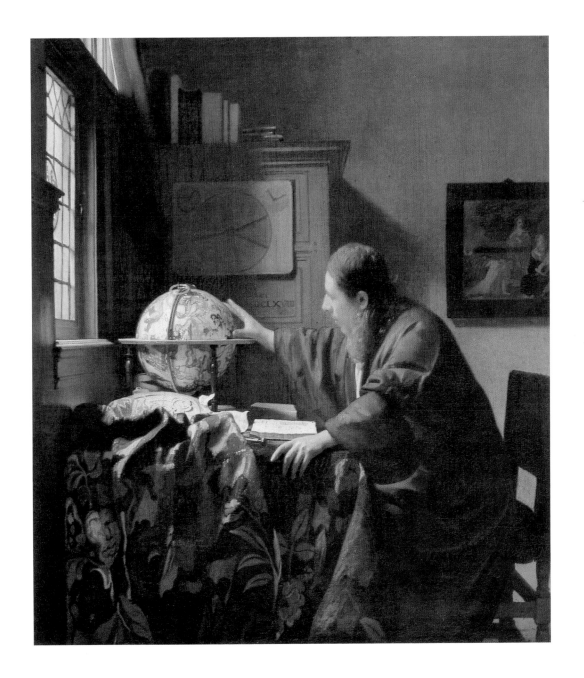

The Geographer

c. 1668
Oil on canvas, 52 × 45.5 cm
Frankfurt, Städelsches
Kunstinstitut und
Städtische Galerie
Apocryphal inscriptions
"Meer" and "I. VER Meer
MDCLXVIIII"

As with *The Astronomer*, to which this picture was probably the pendent, the existence of a refined patron is assumed; according to some, the paintings have to do with Antony van Leeuwenhoek, Delft scientist famous for his microscope studies. The scientist, Vermeer's contemporary, also dabbled in astronomy, and in 1669, soon after the two works were painted, he took and passed a surveyor's examination.

The scene is similar to the one painted in *The Geographer*: the protagonist is shown in a brightly lit room furnished with a table and a wardrobe. The maps and books he uses for his work are scattered carelessly around; other volumes are piled on top of the wardrobe, where a world globe also sits. The geographer is leaning over the table and in his right hand holds a compass; it looks as if he has just lifted his gaze from his maps to look out the window.

Presumably, *The Astronomer* and *The Geographer* conceal a symbolic meaning: its interpretation is fundamentally based on the fact that of the two, one works with celestial things and the other with earthly things. Their attitude seems to be one of faith in research: the former touches the celestial sphere and the second looks to the light and the real world. The presence of a painting of a biblical subject, *The Finding of Moses*, on the rear wall of *The Astronomer* contributes to an interpretation in a theological key. This subject can be associated with the motif of Divine Providence, which guides human destiny.

The composition of this painting has a few interesting stylistic features. The atmosphere is no longer the hushed and thoughtful one of the years around 1665, but vibrates with the dynamism and action concentrated in the figure. Thus, the light shines on the wall with distinct shadows and the geographer's dressing gown has clear-cut, contrasted folds.

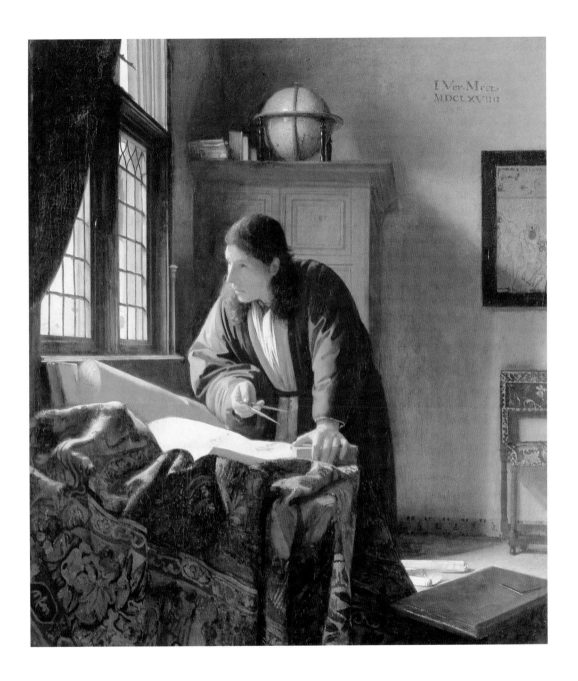

The Lacemaker

c. 1669
Oil on canvas, transferred
to panel
23.9 × 20.5 cm
Paris, Musée du Louvre
Signed "IVMeer"

In 1696, this painting was in the collection of Jacob Dissius, who probably inherited it from the man believed to be Vermeer's patron, Pieter van Ruijven. It entered the Louvre in 1870, after the Museum Boijmans Van Beuningen in Rotterdam was unable to raise the funds needed to purchase it.

In the small canvas, one of Vermeer's most celebrated, a girl is intent on her lacemaking; her gaze is concentrated on her work and on the movement of her hands. The setting is reduced to a minimum since the artist's view is quite close up and the composition informal. There is a corner of a table in the foreground, upon which rests a partially open sewing cushion from which red and white threads spill out, described with simple brushstrokes and extraordinary fluidity. The light comes from the right and shines on the girl's yellow bodice, also passing with particular emphasis over her forehead and fingers. This device allows Vermeer to call attention to the concentration required by this manual activity. The figure of the lacemaker, after all, is recurrent in Dutch painting as a symbol of industriousness and domestic virtue. The moralizing interpretation is confirmed here by the presence on the table of a bound parchment book closed with dark ribbons, probably a bible or a prayer book.

The tendency to leave the objects in the extreme foreground out of focus returns here. Note the tangle of red threads and the sewing cushion tassels. As with optical instruments, this effect is because the gaze is focused on the middle ground, where the lacemaker is. Vermeer may have observed his model through a camera obscura, but we can rule out the possibility that the image on the canvas was obtained by tracing a projection. The same can be said for *The Guitar Player*, painted around 1672, which *The Lacemaker* foreshadows in many respects.

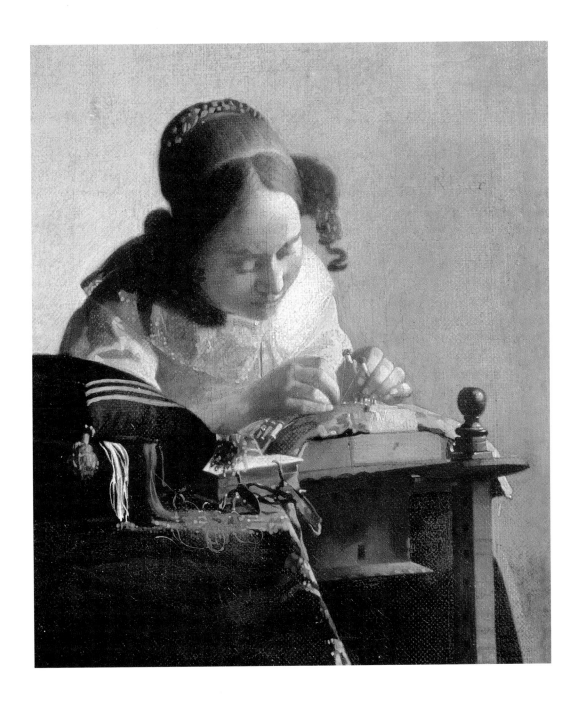

The Love Letter

c. 1669
Oil on canvas, 44 × 38 cm
Amsterdam, Rijksmuseum
Signed "IVMeer"

This painting, which perhaps can be traced to the Bredius collection in alternative to *Mistress and Maid*, entered the Rijksmuseum in 1893. The acquisition was made possible thanks to the involvement of the Rembrandt Association, founded for the purpose of protecting the Dutch artistic heritage.

The Love Letter is the only painting in which Vermeer constructed his scene beyond an open door. The observer's point of view is from a dark anteroom, where a chair, some sheets of music and a faded geographical map on the left can be made out. In the back room, elegant and light-filled, a maidservant has just delivered a letter to her mistress. The woman, who was playing a stringed instrument, turns to the maid with a worried look, her expression much like that shown in *Mistress and Maid*. The maid answers her with a smile; so, it would appear that she wants to reassure her mistress about the good intentions of the missive. The paintings in back of her illustrating two peaceful landscapes seem to presage a positive outcome for the affair. The scene is enriched by several decorative details: the cornice of the mantelpiece, the golden tapestry, a brocade curtain and a series of objects alluding to domestic life are scattered all around. There are a laundry basket, a sewing cushion, a pair of slippers and a broom. It is not clear whether this multitude of secondary elements, never before seen in Vermeer's work, has some bearing on the picture's meaning.

Various considerations have been made in the dating of this work: the sharpness of the scene in the middle-ground, above all, is the same as in such later compositions as *Allegory of the Faith*, where a similar accumulation of minor details can be seen. Furthermore, the device of the sequence of rooms, foreign to Vermeer's oeuvre, seems to have been inspired by paintings made by de Hooch at the close of the 1660s, and in particular, *Couple with a Parrot* of 1668, now in Cologne.

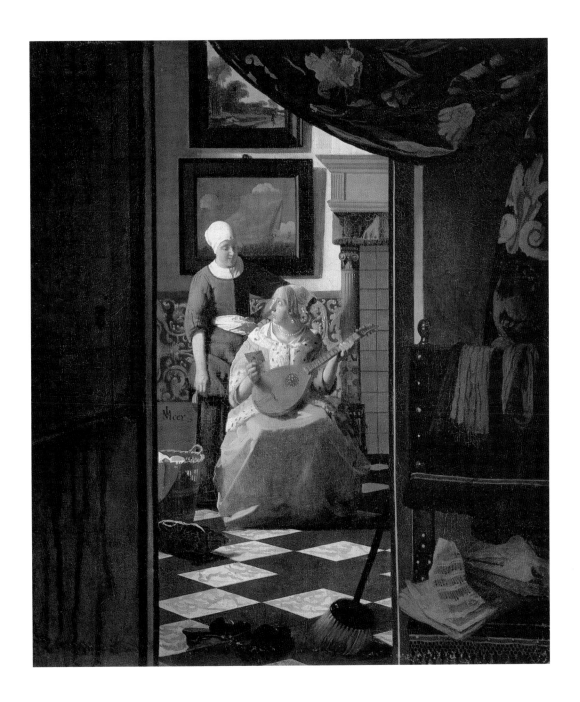

Lady Writing a Letter with Her Maid

c. 1670
Oil on canvas, 72.2 × 59.7 cm
Dublin, National Gallery
of Ireland
Signed "IVMeer"

It seems highly probably that this is the painting "showing two figures, one of which is writing a letter" that Vermeer's widow gave in 1676 as security to a baker to whom she owed an enormous debt. It passed through several collections starting in the eighteenth century, and before it entered the Dublin museum in 1993, it was the focus of dramatic news reports. It was stolen twice from its owner, first by the IRA and later by common criminals.

The theme of the letter returns in this picture: in a room with all of Vermeer's typical features, a woman is busy writing a letter. The maid stands near the window, dreamily looking out of it, her arms crossed in an attitude of waiting; perhaps she is waiting for her mistress to hand her the letter to deliver. The maid's statuary immobility, apparent even in the handling of the folds of her dress, stands in deliberate contrast with the dynamic figure of her mistress, who, in fact, is constructed of oblique lines and illuminated by a harsh light. Vermeer may have been using these means to express the woman's mental tension and her emotional involvement in writing her message. It almost looks as if she is replying to a letter she did not appreciate, the one crumpled up on the floor in front of her desk. It has been suggested that the "painting within the painting" seen on the rear wall has a connection with the scene depicted: it is the *Finding of Moses*, the same painting that can be made out, though smaller, in *The Astronomer*. The biblical story of baby Moses's rescue by the daughter of the pharaoh can be interpreted as a reflection on God's capacity for reconciling the deepest opposites. From here we can return to the subject of the discord provoked by the letter received.

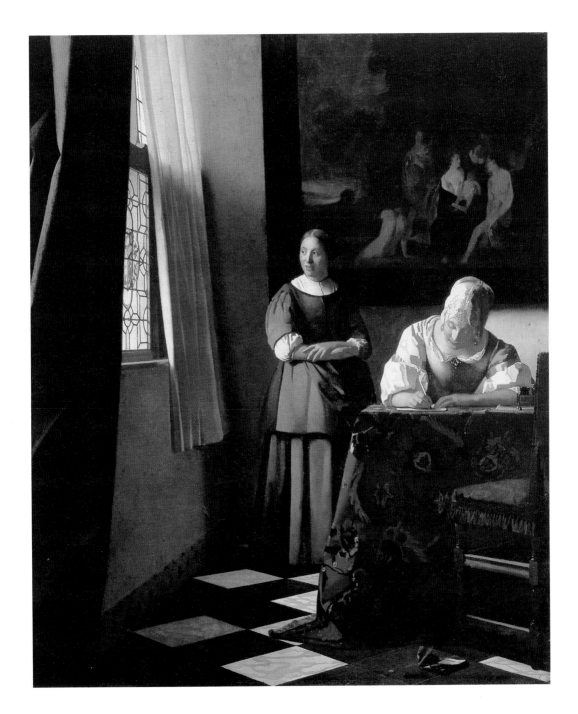

Allegory of the Faith

c. 1670
Oil on canvas, 114.3 × 88.9 cm
New York, The Metropolitan
Museum of Art

At the close of the seventeenth century, *Allegory of the Faith* was in Amsterdam. It is impossible to establish whether the owner had been Vermeer's direct client, although the fact that he was Protestant is clearly in contrast with the deepest meaning of the painting, which some think was actually commissioned by the Jesuits.

Compared to *The Art of Painting*, the subject depicted here is hardly suited to a domestic setting; Vermeer, in any case, did not renounce representing it in the same room, with the brocade curtain in the foreground and the black-and-white tiles. The personification of Faith against the rear wall is dressed in a white and blue gown, an allusion to light and heaven; her right hand raised to her breast indicates that in her heart resides a vigorous faith. Beneath her right foot is a globe, which conveys the idea that faith has the world at her feet. Cesare Ripa's *Iconologia*, translated into Dutch in 1644, inspired all these elements. On the table next to Faith rest a bible, a chalice and a crucifix. This is the most explicit reference to Catholic theology, affirming the central role of the Eucharist and Christ's sacrifice. This significance is reiterated by the presence on the rear wall of a large painting of the *Crucifixion*: the insistence on the theme reveals important connections with Saint Ignatius Loyola's *Spiritual Exercises*. The apple and the snake crushed on the floor, symbols of the Original Sin, complete the picture, along with the glass globe hung from the ceiling, which is a Jesuit motif.

The cold and mannered tone of this painting can be ascribed to the presence of many elements foreign to Vermeer's poetic universe. Similar results, in any case, can be found in all of the artist's output of the 1670s, which shows a half-hearted observance of the classical style reigning in Dutch art of the same period. This is why scholars tend to date the picture to the early 1670s.

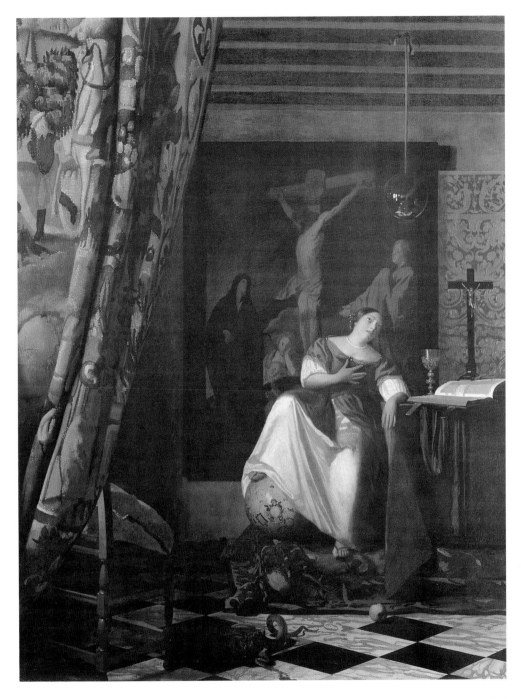

The Guitar Player

c. 1672
Oil on Canvas, 53 × 46.3 cm
London, Kenwood House,
Iveagh Bequest
Signed "IVMeer"

To pay off her debts incurred with a baker, in 1676 Vermeer's widow gave as security two paintings, one showing "a person who is playing the guitar," which can probably be identified with this painting now in London. The canvas dates from the artist's late maturity, and may have been left in his studio following his death. However, the Dissius collection inventory also recorded "a young woman who plays the guitar, very well made."

The painting has the same immediacy as *The Lacemaker*. The point of view is close-up, and the approach unmistakably informal; a young woman is seated, intent on playing a stringed instrument. The girl, who is wearing the yellow satin jacket edged in ermine that appears in many of Vermeer's works, has an open and smiling expression. The direction of her gaze, turned toward an undefined area outside of the composition, enhances the dynamic effect obtained by positioning the figure to one side of the canvas.

The young woman's hairstyle is the same as the girl's in *The Lacemaker*, which has served as a point of reference for the dating. The guitar player's clothing, however, shows an even greater freedom of brushwork: the artist has abandoned any interest in the paint's capacity for rendering texture, and focuses on the color as his means for modeling the planes and the figures. In some areas of the skirt, on the fingers of the left hand, and on the relief of the gilded frame, the colors become intense and radiant.

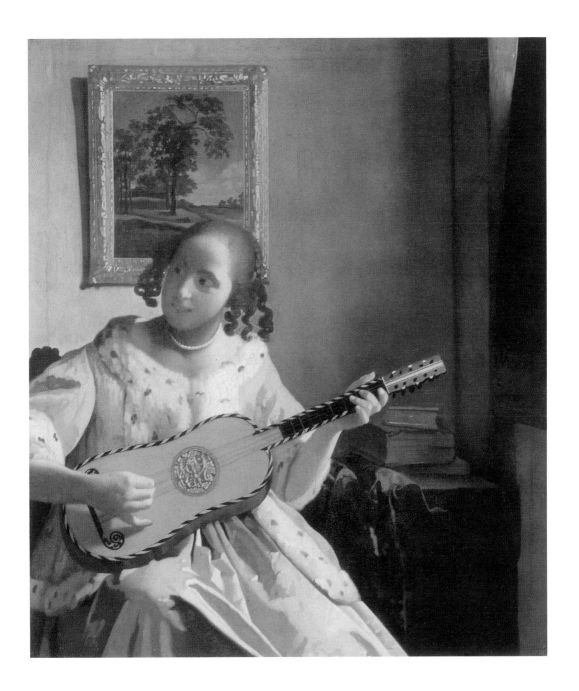

A Young Woman Standing at a Virginal

c. 1672
Oil on canvas, 51.8 × 45.2 cm
London, National Gallery
Signed "IVMeer"

Given the close similarity of this subject to *A Young Woman Seated at a Virginal*, it is difficult to be sure about the first news we have about it. In 1682, for example, a work with a woman playing a virginal is mentioned in the collection of Diego Duarte in Antwerp; another similar one was in the collection of Nicolaes van Assendelft, Delft. The two paintings were reunited for a time in the collection of Thoré-Bürger, Vermeer's "discoverer."

The painting shows an exquisitely dressed young woman playing the virginal in an elegant, richly decorated room. The woman turns her gaze to the viewer, though her expression does not convey any particular emotion apart from a peaceful composure. Two paintings dominate the rear wall: a landscape set in a gilt frame and a *Cupid*, already seen in, among other paintings, *A Maid Asleep*. The reason for this "painting within a painting" provides the key for its interpretation, which, as often happens with music scenes, can be read as a reflection upon love. In this particular case, the scenic atmosphere lends itself to thinking of a pure and chaste love, focused on a single individual: the card that the cupid of the painting holds in his left hand alludes to this, and has reference to a precise emblematic image. On the majolica tiles running along the base are another three small images of cupids.

The most important aspect of *A Young Woman Standing at a Virginal* lies in the style Vermeer achieved, the complete evolution of his late endeavors. The crystalline light, so different from the suffused approach of the 1660s, clearly outlines the profiles of the objects; even the shadows and folds of the drapery are cleanly marked. The sense of quiet meditation and intimacy that pervaded Vermeer's best paintings is gone here, in favor of a cold and decorative elegance.

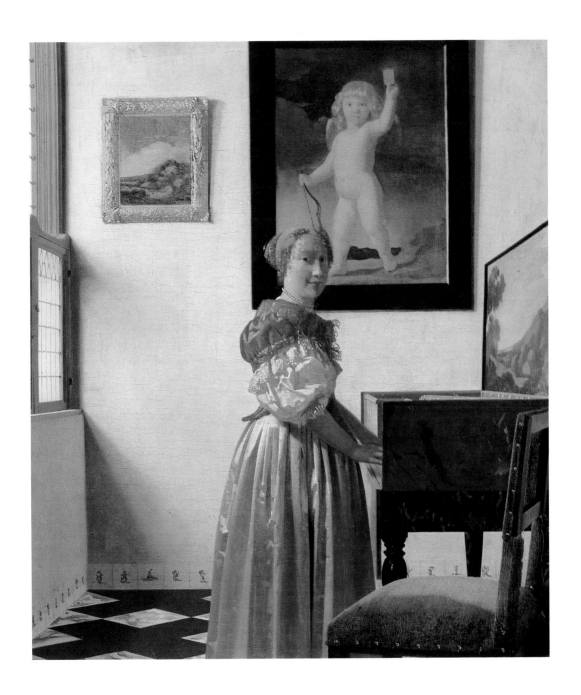

A Young Woman Seated at a Virginal

c. 1675
Oil on canvas, 51.5 × 45.6 cm
London, National Gallery
Signed "IVMeer"

This painting is quite similar in style and subject to *A Young Woman Standing at a Virginal*; in the nonspecific mentions in the seventeenth-century documents, it is impossible to distinguish information about one or the other painting. In addition to the works pointed out in the Duarte and van Assendelft collections, a "lady playing the harpsichord" is mentioned in 1696 in the Dissius collection. Perhaps it was the one that documents place in Antwerp a few years earlier. In any case, it is safe to say that the two paintings followed separate paths from the time of their creation, and, therefore, were not pendents, but simply variations on a theme.

Here again, in this painting, a young woman turns toward the viewer. She keeps her hands on the keyboard of her instrument, which has marbling decorations and a painting on the cover, like the one played by the standing lady. In the foreground, there is a viola da gamba; on the rear wall is a painting of van Baburen's *Procuress*, seen in other of Vermeer's works. A symbolic reading of the scene would draw attention to the contrast between chaste and sensual love: the two musical instruments allude to the former, symbolizing, as in *The Music Lesson* the harmony between the souls of two people who love one another. The painting with *The Procuress* would thus be included here for the sake of contrast, symbolizing profane love.

Critics assign quite a late date to this canvas as a result of an analysis of the brushwork. In some zones, as in the gilt frame and in the woman's dress, Vermeer used flat, summary strokes without worrying about the textures and the volumes, limiting himself to general decorative effects.

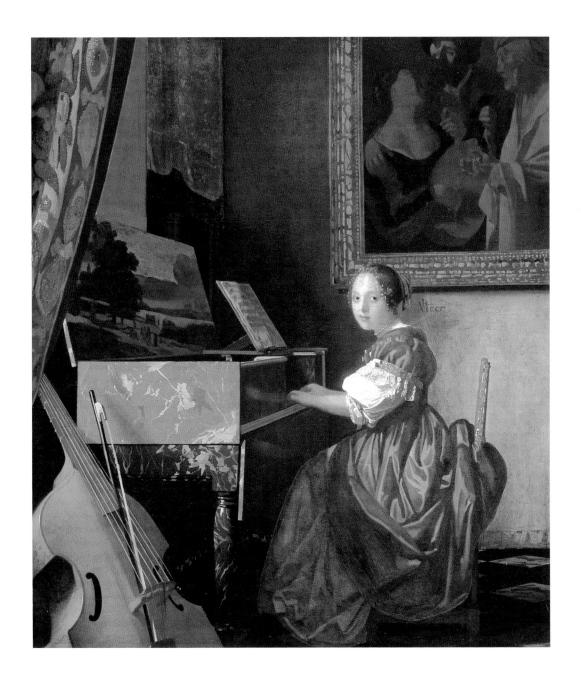

Appendix

Chronological Table

	Life of Vermeer	Historical and Artistic Events
1615	On April 15, in Amsterdam, the painter's parents marry. His father, Reynier Vos, called Vermeer, may already have been at the time a weaver, and he certainly ran a tavern, together with his wife, Digna, located on the market square of Delft.	
1632	The birth of Reynier and Digna's second child, Johannes, called Jan, is reported; they already had a daughter named Gertruy.	Luca Giordano, Spinoza, and the Delft naturalist Antony van Leeuwenhoek are all born; the latter is to become famous for his perfecting of the microscope and discovering red blood cells and spermatozoa. Rubens just finished painting his Saint Ildefonso altarpiece, Rembrandt his *Anatomy Lesson* (The Hague). Bernini finishes the baldachin over the high altar of Saint Peter's in Rome. Galileo publishes his *Dialogue on the Two Chief World Systems*.
1634		The Catholic Netherlands cease to be a sovereign state and return under the rule of Spain. Francesco Borromini designs San Carlo alle Quattro Fontane in Rome.
1638		In September, the queen of France Maria de Medici arrives in Antwerp. The Flemish painter Pieter Brueghel the Younger dies in Antwerp.
1640		The painter Peter Paul Rubens dies in Antwerp.
1647		Frederick Henry, Prince of Orange, dies. His son William II succeeds him. The Dutch writer Pieter de Hooft dies. In Naples, Masaniello leads his revolt against the Spanish viceroy.
1650		In the summer William II lays siege to Amsterdam, but he dies in November. In France, the "Fronde" revolt of the nobility against the Crown, led by the Prince de Condé, forms an alliance with Spain and drives the court of Cardinal Jules Mazarin out of Paris.

	Life of Vermeer	Historical and Artistic Events
1653	Johannes Vermeer marries Catharina Bolnes, who was from a rich, Catholic family of Gouda; according to some sources, the painter secretly embraced his wife's religion. Vermeer joins Saint Luke's Guild, to which the painters Emmanuel de Witte, Paulus Potter, and Carel Fabritius already belong.	Oliver Cromwell establishes his own personal dictatorship in England.
1655	Vermeer's father dies, and the artist probably inherits the tavern and the trade in art works from him. Vermeer's mother lives with her son for a brief period.	The French poet Cyrano de Bergerac dies. The new town hall is inaugurated at Amsterdam. Jacob van Ruisdael paints *The Jewish Cemetery* (Dresden, Gemäldegalerie). In Rome, Pietro da Cortona goes back to painting in the church of Santa Maria in Vallicella.
1656	The year *The Procuress* is dated.	The Dutch painter Gerrit van Honthorst, called "Gherardo delle Notti" (Gerard of the Night Scenes) dies. Velázquez paints *Las Meninas*. Pascal publishes the *Lettres Provinciales*.
1657	Gets a loan of 200 guilders.	
1658		Death of Oliver Cromwell.
1659		With the treaty of the Pyrenées, Mazarin makes the crowning achievement of his diplomatic career, gaining territories from Spain and arranging the marriage of the French dauphin and the Spanish *infanta* Marie Thérèse. The Great Coalition of The Hague was made in reaction to France's growing power.
1660		Marriage of Louis XIV and Marie Thérèse of Spain. The peace of Oliva ends the conflict between Sweden, Poland, Brandenburg and the Holy Roman Empire. Spinoza conceives his *Ethics*.
1661		Cardinal Marazrin dies after dominating the French political scene for twenty years. Louis XIV personally takes power. With his work *The Skeptical Chemist*, Robert Boyle criticizes the prevailing alchemy, ushering in modern chemistry.

	Life of Vermeer	Historical and Artistic Events
1662	In Delft, Vermeer is elected to the governors' board of Saint Luke's Guild.	Charles II of England sells Dunkerque to France for 400 thousand pounds. Spinoza works on his *Ethica ordine geometrico demonstrata*. Molière stages his *Ecole des Femmes*.
1663	Balthasar de Monconys, advisor to the crown of France, as well as alchemist and art lover, visits Delft. He writes in his diary about meeting with Vermeer, whose art, however, he describes in disparaging terms.	
1664		New hostilities between Holland and England. The physicist and naturalist Robert Hooke discovers plant cells using a microscope. The first issue of *Gazzetta di Mantova* is printed; it is the oldest daily in Italy.
1665		The second Anglo-Dutch war breaks out; the Dutch are defeated off Lowestoft.
1667		War between France and Spain over the possession of the Spanish Flanders. The Dutch destroy the English fleet on the Thames. The second Anglo-Dutch maritime war ends in July with the peace of Breda. Gabriel Metsu, painter of scenes of Dutch domestic life, dies. Francesco Borromini dies in Rome.
1668		Holland forms an alliance with England and Sweden as a consequence of Colbert's tariff war.
1669		Rembrandt dies. In Rome, Pietro da Cortona dies.
1670	The artist's mother dies. Once again, he is elected to Saint Luke's Guild governors' board.	William of Orange takes command of the Dutch army. Van Leeuwenhoek experiments with the microscope.
1671	He inherits 648 guilders from his sister Gertruy, the equivalent of two years' pay to an experienced bricklayer.	Holland and Prussia sign an anti-French alliance. Pascal publishes his *Pensées*, Molière dies while performing the lead role of *Le Malade Imaginaire*.

	Life of Vermeer	Historical and Artistic Events
1672	With his fellow townsman and colleague Hans Jordaens, he goes to The Hague, where, together with other painters, including Karel Dujardin, he is asked to evaluate thirteen works that the most respected art dealer of Amsterdam, Gerrit Uylenburgh, son of Rembrandt's dealer, had sold for 30,000 guilders to the elector of Brandenburg, who dismissed them as "rubbish," though the dealer claimed they were the work of prestigious Italian masters. The experts called in confirmed the negative opinion.	Holland is invaded and brutally sacked by French troops.
1673		William of Orange seizes Bonn and frees Utrecht. The English blockade of the Dutch is called off.
1674		With the treaty of Westminster, England puts an end to its war against the United Provinces, obtaining in exchange possession of the Dutch colonies in North America. With the Diet of Regensburg, the Empire, United Provinces and Spain form an anti-French coalition. Leibniz makes his calculating machine.
1675	In March, Vermeer's mother-in-law entrusts him with handling a matter regarding an inheritance. The artist takes a loan of 1,000 guilders. On December 15, "Jan Vermeer, artist who lives in the Oude Langendijk," is buried in the Old Church; he leaves eleven children, eight of whom are still minors. The naturalist van Leeuwenhoek is appointed executor of his estate.	Prussia and Holland defeat France and Sweden at Fehrbellin. The Greenwich observatory is built; Leibniz perfects his system of infinitesimal calculus.

Geographical Locations of the Paintings
(in public collections)

Austria

The Art of Painting
Oil on canvas, 120 x 100 cm
Vienna, Kunsthistorisches
Museum
c. 1666

France

The Astronomer
Oil on canvas, 50 x 45 cm
Paris, Musée du Louvre
1668

The Lacemaker
Oil on canvas, transferred
to panel, 23.9 x 20.5 cm
Paris, Musée du Louvre
c. 1669

Germany

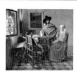

*Gentleman with Girl Drinking
(The Glass of Wine)*
Oil on canvas, 65 x 77 cm
Berlin, Staatliche Museen
Berlin, Gemäldegalerie
1661–1662

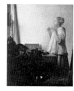

Woman with a Pearl Necklace
Oil on canvas, 51.2 x 45.1 cm
Berlin, Staatliche Museen
Berlin, Gemäldegalerie
c. 1664

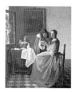

*The Girl with a Glass
of Wine*
Oil on canvas, 77.5 x 66.7 cm
Brunswick, Herzog Anton
Ulrich-Museum
c. 1659

The Procuress
Oil on canvas, 143 x 130 cm
Dresden, Gemäldegalerie
Alte Meister
1656

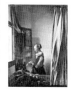

*Woman Reading a Letter
by an Open Window*
Oil on canvas, 83 x 64.5 cm
Dresden, Gemäldegalerie
Alte Meister
c. 1657

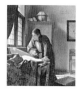

The Geographer
Oil on canvas, 52 x 45.5 cm
Frankfurt, Städelsches
Kunstinstitut und
Städtische Galerie
c. 1668

Great Britain	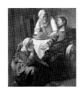 *Christ in the House of Martha and Mary* Oil on canvas, 160 x 142 cm Edinburgh, National Gallery of Scotland *c.* 1655	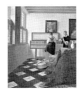 *Gentleman and Lady at the Virginal (The Music Lesson)* Oil on canvas, 74 x 64.5 cm London, Buckingham Palace, Royal Collections *c.* 1662
	The Guitar Player Oil on canvas, 53 x 46.3 cm London, Kenwood House, Iveagh Bequest *c.* 1672	*A Young Woman Standing at a Virginal* Oil on canvas, 51.8 x 45.2 cm London, National Gallery *c.* 1672
	A Young Woman Seated at a Virginal Oil on canvas, 51.5 x 45.6 cm London, National Gallery *c.* 1675	
Ireland	*Lady Writing a Letter with Her Maid* Oil on canvas, 72.2 x 59.7 cm Dublin, National Gallery of Ireland *c.* 1670	
Holland	*Diana and Her Companions* Oil on canvas, 97.8 x 104.6 cm The Hague, Koninklijk Kabinet van Schilderijen, Mauritshuis *c.* 1655	*View of Delft* Oil on canvas, cm 96.5 x 117.5 The Hague, Koninklijk Kabinet van Schilderijen, Mauritshuis *c.* 1660

Holland

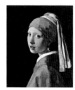

Girl with a Pearl Earring
Oil on canvas, 44.5 x 39 cm
The Hague, Koninklijk
Kabinet van Schilderijen,
Mauritshuis
c. 1665

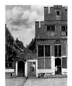

The Little Street
Oil on canvas,
53.5 x 43.5 cm
Amsterdam, Rijksmuseum
c. 1657

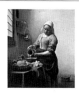

The Milkmaid
Oil on canvas,
45.4 x 40.6 cm
Amsterdam, Rijksmuseum
c. 1659

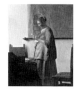

*Woman in Blue Reading
a Letter*
Oil on canvas,
46.6 x 39.1 cm
Amsterdam, Rijksmuseum
c. 1663

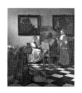

The Love Letter
Oil on canvas, 44 x 38 cm
Amsterdam, Rijksmuseum
c. 1669

United States

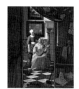

The Concert
Oil on canvas, 72.5 x 64.7 cm
Boston, Isabella Stewart
Gardner Museum
c. 1665

A Maid Asleep
Oil on canvas,
87.6 x 76.5 cm
New York, The Metropolitan
Museum of Art
1656–1657

Officer and Laughing Girl
Oil on canvas, 50.5 x 46 cm
New York, The Frick
Collection
1655–1660

Girl Interrupted at Her Music
Oil on canvas,
39.3 x 44.4 cm
New York, The Frick
Collection
c. 1660

United States

Woman with a Lute
Oil on canvas,
51.4 x 45.7 cm
New York, The Metropolitan
Museum of Art
early 1660s

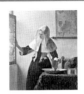

Young Woman with a Water Pitcher
Oil on canvas, 51.4 x 45.7 cm
New York, The Metropolitan
Museum of Art
early 1660s

Study of a Young Woman
Oil on canvas, 44.5 x 40 cm
New York, The Metropolitan
Museum of Art
1665–1667

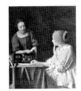

*Mistress and Maid
(Maidservant Holding a
Letter out to Her Mistress)*
Oil on canvas, 90.2 x 78.7 cm
New York, The Frick
Collection
1665–1670

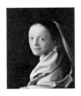

Allegory of the Faith
Oil on canvas,
114.3 x 88.9 cm
New York, The Metropolitan
Museum of Art
c. 1670

Saint Praxedes
Oil on canvas,
101.6 x 82.6 cm
Princeton, Barbara Piasecka
Johnson Collection
1655

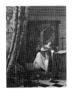

*Woman Holding a Balance
(The Weighing of the Pearls)*
Oil on canvas,
40.3 x 35.6 cm
Washington, National
Gallery of Art
c. 1664

A Lady Writing
Oil on canvas, 45 x 39.9 cm
Washington, National
Gallery of Art
c. 1665

Girl with the Red Hat
Oil on canvas, 23.2 x 18.1
cm
Washington, National
Gallery of Art
c. 1665

Girl with a Flute
Oil on canvas, 20 x 17.8 cm
Washington, National
Gallery of Art
1665–1670

Writings

THE MAPPING IMPULSE IN DUTCH ART

Vermeer's *Art of Painting*, a work that illuminates the resemblance between pictures and maps, is a promising place to begin. In size and theme this is a unique and ambitious work that draws our attention to a splendid representation of a map. We are looking into a painter's studio. The artist has started to render the leaves of the wreath on the head of a young woman, one of Vermeer's familiar models, who here represents, so we have been told, Clio, the muse of history bedecked with her emblematic accoutrements as described by Ripa. The great map, hung so as to fill the back wall before which Vermeer has situated painter and model, has not gone unnoticed by art historians. It has been plumbed for its moral meanings: its presence interpreted as an image of human vanity, a literal rendering of worldly concerns; and its depiction of the northern and southern Netherlands interpreted as an image of a lost past when all provinces were one country (a historical dimension borne out perhaps by the painter's old-fashioned dress and the Hapsburg eagles on the chandelier). Most recently the scrupulously careful rendering has enabled the map to be identified as a particular one preserved today in only a single copy in Paris. Seen this way, Vermeer's map, inadvertently, is a source for our knowledge of cartographic history.

But these interpretations all overlook the obvious claim that the map makes on us as a piece of painting in its own right.[1] There are, of course, many pictures of the time that remind us of the fact that the Dutch were the first who seriously produced maps as wall-hangings—this being only a part of the wide production, dissemination, and use of maps throughout the society.

But nowhere else does a map have such a powerful pictorial presence. When compared with the maps in the works of other artists, Vermeer's maps might all be said to be distinctive. While [Jacon] Ochtervelt, for example, merely indicates that a map is on the wall, testified by a faint outline on a tawny ground, Vermeer always suggests the material quality of varnished paper, paint, and something of the graphic means by which the land mass is set forth. It is hard to believe that the same map is represented by Ochtervelt and by Vermeer. Each of the maps in Vermeer's works can be precisely identified. But the map in the *Art of Painting* is distinctive in other ways. It is the largest map and also the most complex assemblage of any in Vermeer's works. The Netherlands is at the edge of a ship-filled sea, framed by topographical views of her major cities, emblazoned with several cartouches, explained beneath by a text, and elegantly titled in clear letters set across its upper edge. (The orientation of printed maps was not yet fixed at the time, and the west coast rather than the northern border of Holland appears at the top of the map.) What is more, it is a map whose original combined the four kinds of printing then available for use in maps—engraving, etching, woodcut, and moveable type for letters. In size, scope, and graphic ambition it is a summa of the mapping art of the day, represented in paint by Vermeer.

And in this respect—as a representation—it is also different from other maps in Vermeer's paintings. In every other work by Vermeer where there is a map it is cut by the edge of the picture. But here we are meant to see it all because we are meant to see it in a different light. Although it is skimmed by a bit of tapestry, and a small area is hidden by the chandelier, the entire extent of this huge map is made fully visible on the wall. Vermeer combines the richly painted surface of the map in his Frick painting with

the weight of the varnished paper of the man behind the *Woman Reading a Letter* in Amsterdam to give this map an astonishing material presence. Other objects in the studio share this crafted presence—the tapestry, for example with threads hanging loose from its back side. But the tapestry is located, as its position in the painting suggests, at the edge. It leads us in to the painting while the map is itself presented as a painting. (The red tip of the maulstick matches the red paint on the map—but then as if to caution us against making too much of the fact the artist's stockings share the shade.) Vermeer irrevocably binds the map to his art of painting by placing his name on it. *I Ver-meer* is inscribed in pale letters at the point where the map's inner border meets the blue cloth that stands out stiffly behind the model's neck. In no other painting does Vermeer claim that the map is of his own making. Vermeer's claim to the identity of mapmaker is powerfully confirmed elsewhere in his work. The only two male figures to whom he devoted entire paintings—the *Astronomer* in a private collection in Paris, and the *Geographer* in Frankfurt—were also by profession makers of maps and they encompass the heavens and the earth between them.

The *Art of Painting* comes late in the day for Dutch painting and late in Vermeer's career. It stands as a kind of summary and assessment of what has been done. The poised yet intense relationship of a man and a woman, the conjunction of crafted surfaces, the domestic space—this is the stuff of Vermeer's art. But here it all has a paradigmatic status due not only to its historic title but to the formality of its presentation. If this map is presented like a painting, to what notion of painting does it correspond? Vermeer suggests an answer to this question in the form of the word *Descriptio* prominently written on the upper border of the map just where it extends to the right of the chandelier over the

easel. This was one of the most common terms used to designate the mapping enterprise. Mapmakers or publishers were referred to as "world describers" and their maps or atlases as the world described.[2] Though the term was never, as far as I know, applied to a painting, there is good reason to do so. The aim of Dutch painters was to capture on a surface a great range of knowledge and information about the world. They too employed words with their images. Like the mappers, they made additive words that could not be taken in from a single viewing point. Theirs was not a window on the Italian model of art but rather, like a map, a surface on which is laid out an assemblage of the world.

But mapping is not only an analogue for the art of painting. It also suggested certain types of images and so engaged Dutch artists in certain tasks to be done. Vermeer confirms this kind of relationship between maps and pictures. Let us consider his *View of Delft*: a city is viewed as a profile, laid out on a surface seen across from the water from a far shore with boats at anchor and small foreground figures. This was a common scheme invented for engraved topographical city views in the sixteenth century. The *View of Delft* is an instance, the most brilliant of all, of the transformation from map to paint that the mapping impulse engendered in Dutch art. And some years later in his *Art of Painting* Vermeer recapitulated the map-to-painting sequence, for the small but carefully executed city views that border the map return his own *View of Delft* to its source. Vermeer puts the painted city view back into the mapping context from which it had emerged as if in acknowledgment of its nature.

Seen from our perspective, this mapping-picture relationship might seem unusual. In the study of images we are used to treating maps as one kind of a thing and pictures as something else. If we exclude the rare occasions when a

landscape picture is used to serve the mapping of a region—as when the U.S. Congress in the 1850's commissioned landscape lithographs of the West in preparation for choosing a route for the continental railroad—we can always tell maps and landscapes apart by their look.[3] Maps give us the measure of a place and the relationship between places, quantifiable data, while landscape pictures are evocative, and aim rather to give us some quality of a place or the viewer's sense of it. One is closer to science, the other is art. This general, though casually held view—casual because it does not normally seek out the possible philosophical grounding—is upheld professionally. Cartographers are clearly a group separate from artists even as students of cartography are separate from historians of art. Or at least that is how it was until recently. We are witnessing a certain weakening of these divisions and the attitudes that they represent. Art historians, less certain that they can stipulate which images count as art, are willing to include more kinds of human artifacts and makings in their field of study. A number have turned to maps.[4] Cartographers and geographers for their part, in keeping with a related intellectual revolution of our time, are newly conscious of the structure of maps and their cognitive basis. A distinguished geographer put the change this way: while once it was said "that is not geography which cannot be mapped," now it is thought that "the geography of the land is in the last resort the geography of the mind."[5] Jasper John's *Map* is a painter's version of this thought. Indeed, the meeting or at least approaching of the different fields is evident today in the works of a number of artists who are making maps.

Students of maps have never denied the artistic component of the maps themselves. It is a commonplace of cartographic literature that maps combine art and science, and the great age of Dutch seventeenth-century maps offers a prime example of this. This is illustrated in the cartouche pairing two female figures at the top left corner of the map represented in Vermeer's *Art of Painting*: one figure bears a cross-staff and compasses while the other has palette, brush, and city view in hand. Decoration—whether in the form of cartouches and other materials such as portraits and city views or built into the use of a map as a domestic wall-hanging—is acknowledged and studied. "Decorative" maps constitute a specific body of cartographic material. But inevitably such decorative aspects or uses are considered to be secondary to the real (scientific) aims of mapmaking. There is assumed to be an inverse proportion between the amount of art displayed and the amount of information conveyed. Art and science, even when combined are in some conflict. A recent and interesting study by a geographer of the historical links between cartography and art had this to say:

Mapmaking as a form of decorative art belongs in the informal, prescientific phase of cartography. When cartographers had neither the geographical knowledge nor the cartographic skill to make accurate maps, fancy and artistry had free reign.[6]

There is of course some truth to this, but it is stated at the expense of understanding the prescientific cartography in its own appropriate terms, in the spirit in which it was done. While cartographers set aside the decorative or picture-like side of maps, art historians for their part have done the same with the documentation of art. "Mere topography" (as contrasted with "mere decoration") is the term here. It is used by art historians to classify those landscape pictures or views that sacrifice art (or perhaps never rise to it) in the name of the recording of place. Cartographers and art historians have been in essential agreement in maintaining

boundaries between maps and art, or between knowledge and decoration. They are boundaries between maps and art, or between knowledge and decoration. They are boundaries that would have puzzled the Dutch. For at the time when maps were considered to be a kind of picture and when pictures challenged texts as a central way of understanding the world, the distinction was not firm. What should be of interest to students of maps and pictures is not where the line was drawn between them, but precisely the natures of their overlap, the basis of their resemblance.

[1] On Vermeer's map as a source for cartographic history see James Welu, "Vermeer: His Cartographic Sources," *The Art Bulletin* 57 (1975):529–47 and "The Map in Vermeer's *Art of Painting*," *Imago Mundi* 30 (1978):9–30. Footnotes 54 and 56 in the first article list the major studies of the map and of the interpretation of the painting itself. In a brief and perceptive footnote to a study by J. G. van Gelder, J. A. Emmens connects the map to the topographic ambitions of the art of painting. See J. G. van Gelder, *De Schilderkunst van Jan Vermeer* (Utrecht: Kunsthistorisch Instituut, 1958), p. 23, n. 14.

[2] To cite but a few from a great number of examples: Gemma Frisius titled his 1533 treatise on triangulation *Libellus de locorum describendorum ratione . . .* , the Dutch rendering of which was *Die maniere om te bescrijven de plaetsen ende Landtschappen* (Amsterdam, 1609); Petrus Montanus refers to Jodocus Hondiuo as "De alder-vermaerste en best-geoffende Cosmagraphus ofte Wereltbeschrijver van onse eeuw" in his introduction to the first Dutch edition of the Mercator-Hondius Atlas (1634).

[3] Alfred Frankenstein, "The Great Trans-Mississippi Railway survey," *Art in America* 64 (1976):55–58.

[4] The major examples in the field of Dutch art are the several studies by James Welu, and the exhibition catalogue *The Dutch Cityscape in the 17th Century and its Sources* (Amsterdam, Amsterdams Historisch Museum, 1977). For a general study of cartographical material published in Amsterdam during the seventeenth century with a fine eye for its cultural place and relationship to art and artists, see *The World on Paper* (Amsterdam, Theatrum Orbis Terrarum, 1967), compiled on the occasion of the International Conference on Cartography by Marijke de Vrij. Both exhibitions were held under the auspices of the Amsterdam Historical Museum, which has been in the forefront of showing the ties that bind art to society.

[5] J. Wreford Watson, "Mental Distance in Geography: Its Identification and Representation," unpublished MS of a paper delivered at the twenty-second International Geographic Congress, Montreal, 1972.

[6] Ronald Rees, "Historical links between Cartography and Art," *Geographical Review* 70 (1980):62. See also P. D. A. Harvey, *The History of Topographical Maps* (London: Thames and Hudson, 1980).

Concise Bibliography

Alpers, Svetlana. *The Art of Describing: Dutch Art in the Seventeenth Century.* Chicago: University of Chicago Press, 1984.

Frantis, Wayne E., ed. *The Cambridge Companion to Vermeer.* Cambridge: Cambridge University Press, 2001.

Israel, Johnathan. *The Dutch Republic: Its Rise, Greatness, and Fall 1477–1806.* New York: Oxford University Press, 1998.

Liedtke, Walter, Michiel C. Plomb, and Axel Ruger. *Vermeer and the Delft School.* New York: Metropolitan Museum of Art, 2001.

Montias, John Michael. *Vermeer and His Milieu.* Princeton: Princeton University Press, 1991.

Schama, Simon. *The Embarrassment of Riches: An Interpretation of Dutch Culture in the Golden Age.* New York: Alfred A. Knopf, 1987.

Snow, Edward A. *A Study of Vermeer.* Berkeley: University of California Press, 1994.

Steadman, Philip. *Vermeer's Camera: Uncovering the Truth Behind the Masterpieces.* New York: Oxford University Press, 2002.

Wheelock, Arthur K., Jr. *Johannes Vermeer.* Washington, D. C.: National Gallery of Art, 1995.

Wolf, Bryan Jay. *Vermeer and the Invention of Seeing.* Chicago: University of Chicago Press, 2001.